CULTIVATING KINGDOM *Creativity*

A Practical Guide to Activating and Releasing Supernatural Encounters through
Prophetic Arts in your Personal life, your Church, and your Community

THERESA DEDMON

Cultivating Kingdom Creativity
A Practical Guide to Releasing Supernatural Encounters through
Prophetic Arts in your Personal life, Church, and Community

Copyright © 2009 by Theresa Dedmon Ministries, All Rights Reserved
ISBN # 978-1-61658-519-8
Graphic Design by Amy Rochelle Watson

Additional Contributing Authors:
Melissa Cordell
Amy Rochelle Watson
Janet Richards
Kristen D'Arpa
Jonathan Caleb Matthews
Tiffany Christensen
Francesco Sideli

To order more copies of this book or to contact the author, please email: orderpropheticartsmanual@gmail.com
For more information on Bethel Church, please visit www.ibethel.org

Printed in the United States of America

✦ ACKNOWLEDGEMENTS ✦

Thank You to God for inspiring this book and being the Master Painter in this resurgence of the arts!

Most of all, I would like to thank my husband, Kevin, who believed in me long before I believed in myself. Thanks for sacrificing for my dreams to come true.

To my children, Chad, Alexa, and Julia - You have brought me such joy and love! Let's travel the world together, releasing people to know who they are and know who He is as we preach, sing, and see people transformed.

I would like to acknowledge Kris Vallotton who believed in me in 2003, giving me the prophetic word to go forward and create a prophetic arts world at Bethel School of Supernatural Ministry. You have been a steady supporter as I have launched into the arts around the globe.

I cannot thank Bill and Beni Johnson and Bethel staff enough for the empowering culture you have created, which has given me wings to fly. Dreams come true because you have allowed all of us the freedom to dream from heaven's perspective.

I want to thank all of my students, peers like Renee Cooper, Trisha Wheeler, and Ken Petranek who have been a part of this movement to see the arts transformed for His glory!! I love you all so much!!

Thanks to all of our contributing writers and graphic designer who have given of their time to help with this manual - I couldn't have done it without you! Also, thanks to Francesco Sideli, Caleb Matthews, and Tiffany Christiansen for building a structure of creativity within our School of Ministry this year, where others can thrive and grow. Thank you to my other BSSM interns - Adam Short and Dustene Mather-Pike - for your faithful love and support!

Lastly to my dream duo, Melissa Cordell and Kristen D'Arpa who have been there with me throughout the process of this collaborative, creative venture in bringing the paints and palette together into one manual.

I love you all!

Theresa

TABLE OF CONTENTS

Introduction

Chapter 1: *What is Prophetic Art?* 1.

Chapter 2: *You Were Born to Create* 13.

Chapter 3: *Calling Out the Gold in Others* 25.

Chapter 4: *Intercession Through the Prophetic Arts* 35.

Chapter 5: *Prophetic Arts in Worship* 43.

Chapter 6: *Teaching Prophetic Arts to Children* 51.

Chapter 7: *Teaching Prophetic Arts to Young Adults* 59.

Chapter 8: *Healing Through the Prophetic Arts* 65.

Chapter 9: *Prophetic Drama, Writing and Music* 75.

Chapter 10: *Prophetic Dance* 87.

Chapter 11: *Prophetic Arts in the Marketplace* 97.

Chapter 12: *Prophetic Arts Supernaturally Impacting the Nations* 107.

Conclusion 119.

Appendix of Prophetic Arts Resources 121.

Additional Resources for Cultivating a Kingdom Lifestyle 133.

INTRODUCTION

As you picked up this manual, many of you might be wondering about the relevance supernatural arts can have on a person who is stewarding revival. History tells us that music, film, visual arts and prophetic arts are agents of shifting culture. Now God is going to display another move of His Spirit through the arts so that He can touch millions of lives for His glory. He is inviting the church to be a key player in releasing His creativity outside of the box of normal Christianity. I am inviting you to discover God-breathed creativity, which has the power to bring people into encounters with the Spirit of God. There is a vast difference between creativity that comes from performance and creativity that is birthed through His presence. As you hear the testimonies about how different types of artistic expressions are transforming culture in Redding, California, through Bethel Church and Bethel School of Supernatural Ministry, you will receive an impartation and grace to then take it for your city, church, and personal life. Our desire is for our ceiling, the greatest things we've seen and experienced, to become your floor, the place you begin your adventure in God! Find out how healing and prophetic ministry can go to another level through creativity!

We are about to see a new Holy Spirit-led resurgence of the arts, which uncorks heaven's new wine. This is a place where people are free to create and explore what heaven is saying through all the varied art forms. It is our desire that every country, city, church, man, woman, and child know their identity as a creator made in the image of God, free to create works that glorify the Creator. We were born to paint pictures, write books, and produce films and theatre which go way beyond what we have seen up to this point in time! There will be an explosion of color, sounds movement, and words, and all will point to this cumulative moment in history, when Jesus reveals what His Bride is to be for all the world to see! She has a song, a dance, a poem, and a drama to awaken the world to His truth, a truth that transcends the colorless imitation of a Jesus with no creativity or power to transform. I believe the best novels, most beautiful works of art, and greatest films and theatrical productions are going to be created through the power of the Holy Spirit living inside us, as we co-labor with heaven.

In this manual, we desire to give you tools to transform yourself, your church, and your community. At the end of each chapter are exercises that you can do to begin to activate your prophetic gifts in the different art forms. We also exhort you to write out your testimonies at the end of each chapter and see what can happen as you apply these principles to your life. These activation points can also be used in a group setting, in which people partner together creatively with the Holy Spirit.

Special Message to professional visual and performing artists: I believe that your giftings and your experience have incredible power. Many of our churches throughout the world have not understood the wonderful artistic creative genius latent within the people that sit in pews or chairs each Sunday, not knowing their value in the body of Christ. I heartily believe that your time has come and your place in the body of Christ will once again become both visible and tremendously relevant. As you review and look through the pages of this manual, let the Holy Spirit give you fresh insight into how His Presence can take your artistic expression to the next level. It is our desire to see an artistic community emerge, which carries the heartbeat of heaven.

The best novels, most beautiful works of art, and greatest films and theatrical productions are going to be created through the power of the Holy Spirit.

Please visit my website at www.theresadedmonministries.com for more testimonies on what God is doing in the arts here at Bethel and around the world. We would love for you to share your testimonies as well about what God is doing through you and in your church to transform culture and bring glory to God thought the arts!

Enjoy! Who knows? You may never create anything ordinary again!

CHAPTER 1
What Is Prophetic Art?

Releasing the New Renaissance *Artists:* BSSM Team at San Francisco Prophetic Art Conference

Life is meant to carry a song, a dance, a drama, and a picture.

This is the stuff that life is made out of - creativity which carries life and

speaks to every type of person and to every kind of nation.

Imagine a world void of color, sound, movement, and images. Who would or could live without the creativity of the arts expressed in nature and through artisans? The redemptive art forms carry the beauty of God for all to see. A sunset mirrors His ever-changing glory, His longing to surprise us with colors, streaks of light which morph with every tick of the clock. Life is meant to carry a song, a dance, a drama, and a picture. This is what life is made of - creativity which carries life and speaks to every type of person and to every kind of nation. It is like the modern day tongues described in Acts 2 - everyone can hear God speaking to them in their own language through the prophetic arts! In fact, art prophesies both positively and negatively even when people don't know what prophecy is.

> *The redemptive art forms carry the beauty of God for all to see.*

Many people have tried to decipher what was happening in past cultures by studying the various art forms that were popular during each era. All the various forms of art are ways for mankind to express what they were feeling and what was relevant to them at that time. Art can also influence culture to think and believe a certain way. For instance, the Vietnam War was highly influenced by the press footage taken, the music written, and the films made during that time. We are now moving into a prophetic, Kingdom "age" where the arts can be used to influence our secular culture by bringing heaven to earth through all forms of creative expression! God wants the voice of the arts to reflect His love and His heart. This is our call: to use our creativity to prophesy about God's love!

A working definition for prophetic art is *man partnering with God and creating from our intimacy with Him in ways that reflect and display His heart of love.* Prophetic art is positive, encouraging, and uplifting (I Corinthians 14:3). It reveals God's nature and desire for man, inviting people to wonder and understand their place in history. "Supernatural, prophetic art" is Holy Spirit-led, and relies upon a current word that God is speaking.

At Bethel Church in Redding, California, we are seeing the arts bring healing and transformation. The arts are literally shaping the destinies of people, and creating worlds of life and hope. Art in our present culture can be created for the sole purpose of enjoyment, beauty, or to express a point of view. Prophetic art takes it a step further and prophesies about who God is through color, sound, melodies, scripts, film, drama, fashion, and dance. It is alive, because it is a living and active "rhema" word to those who are hungry and are open.

This is not just happening in Redding, but prophetic arts are sweeping across the globe. I hear countless stories about how people have been either healed or set free through the Arts. *Charisma Magazine* writer, Julia Luken tells about how the arts are transforming others:

GANGS ARE TRANSFORMED

The scarred intersection on Chicago's north side was the battleground for a dozen rival street gangs. At the corner of Sheridan Road and Sunnyside Avenue, memorials marked the spot where slain gang members had fallen. But in the space of a few weeks, the violence subsided and the trade from the drug houses disappeared.

What brought about this startling transformation? Incredibly, a piece of art! A vivid mural depicting creation's beauty, sin's destructive power and Jesus' love for all races. Artist Greg King invited neighborhood teenagers and graffiti artists to join in. The result was a striking image that won the respect of all the gang leaders. They ordered their members not to deface it! The shootings stopped, according to Brian Bakke, a former staff member at a nearby church. "It became hallowed ground," he told *Charisma*. The mural, Bakke suggests, is evidence of something much bigger.

Across America and around the world, Holy Spirit-inspired art is piercing the darkness, bringing God's healing touch to troubled souls and His breath of life to the spiritually dead. Christian artists are using their God-given talents to minister in the ghettos, on the beaches, in shopping malls and in prisons – everywhere people need Jesus.

"For too long, the church has neglected the imagination and the wonder of art," comments Colin Harbinson, a leader of the growing art-in-mission movement. "This is a new day for art and the language of imagination. God is about to do something that we have only dreamt of." Mural painter King agrees. "This street was the garbage can," says the 36-year-old artist, who lives in Brooklyn, New York. "But we created a piece of beauty ... an outpouring of God's love. I think the gang members felt it."

Bakke, former community director at Uptown Baptist just two blocks from the mural, recalls the gang leaders' initial response to the idea. "They said: 'If you're gonna paint nice pictures with positive thoughts, forget it.' We explained the mural would portray the destructive power of sin and the unity of all people in Jesus. 'Go ahead,' they told us. 'Jesus is OK.'" The intense imagery spoke to the gang members - the beauty of God's creation wrecked by sin, symbolized by a mace shattering the world; the words "hatred," "lust," "racism" and "envy" springing forth; shards flying into the adjoining image of Jesus embracing all peoples.

"Most evangelical Christians are beholden to the spoken word," says 44-year-old Bakke, a Chicago native. "But visual art is powerful, and the Holy Spirit uses our creativity."

STANDING ON HOLY GROUND

That's what British artist Paul Hobbs is doing in England. His *Holy Ground* shoe-art display is causing a stir in churches, schools, shopping malls and even at Oxford University, where a chapel minister reported: "Many students and others have found it to be incredibly moving. We had 50 people praying around it this morning." Not bad for a bunch of old shoes.

Hobbs spent two years tracking down Christians around the world whose shoes tell the stories of their inspiring journeys of faith. The 30 pairs include a former prostitute's high-heeled stilettos, an itinerant evangelist's worn-out sandals and the shoes of a former Muslim woman in Asia who came to faith in Christ through a vision of Jesus.

Hobbs, 44, who lives in southern England, came up with the idea after receiving a vision from the Holy Spirit while in prayer. He pictured shoes of all types, along with bare feet, and sensed Moses' encounter with God, when Moses removed his sandals because he was on "holy ground."

Hobbs sets up the art display in a circle on the floor, so that people can walk around it, looking at the shoes and reading the stories that accompany them. Hobbs' favorite pair is the unique sandals of an African evangelist who treks miles on foot and is often persecuted and beaten for the gospel's sake. The sandals – made out of old rubber tires – still have mud on the soles.

Perhaps the most emotive "shoe story" is told by Rosemarie's shoes. Rosemarie's father was Adolph Hitler's bodyguard for the 1936 Olympic Games, and Hitler was her godfather. Her dad – a Christian – risked his life to help persecuted Jews escape Nazi Germany before World War II. In 1938, he was forced to swallow a cyanide pill.

Many people slip off their own shoes as a sign of respect as they circle *Holy Ground.* In one shopping center, hundreds of people stopped to look, including Muslims who appreciated the custom of going barefoot.

"I often wonder what Muslims make of it," Hobbs admits. For many, *Holy Ground* is an emotional experience. "I've seen people in tears ... some sobbing," Hobbs says. Sometimes, people are convicted about their own lukewarm walk with Christ and their need to run a strong race of faith.

One little girl, Hobbs recalls, came to view the display every day of the exhibition and asked her parents to read her a different story each time. Examples like this, Hobbs says, demonstrate that the Holy Spirit uses art He has inspired to probe the hearts and minds of young and old alike, crossing generational, cultural and racial lines.

THE POPE CALLS FOR A NEW RENAISSANCE

On November 21st, 2009, the Pope called for an Arts Summit to be held in the Sistine Chapel, inviting 500 renowned artists to join him to discuss how arts and faith can come together. In response, the Protestant Church linked with the Catholic Church's desire and made it a worldwide day dedicated to the arts! God is uniting artists from all different denominations to come together! Churches worldwide were being beckoned to join with painters, dancers, writers, photographers, singers, actors, sculptors, musicians, and filmmakers... artists of all types... to begin a "New Renaissance" where the church takes back the arts for God's glory!

God wants us to take back the arts! This all starts as we understand our inheritance.

As Christians we have dual citizenship; our real home lies in heaven. Many people do not understand that they are *already* seated with Christ in heavenly realms (Ephesians 1:3). What does earth look like from *heaven's* perspective? When we think about the arts and the act of creating, most of us start with the concept of earthly learning and ability, and we *remain* there. I love studying the Gospel accounts when Jesus explains higher principles to the disciples and they just don't *get it.* For instance, they try to understand how to feed five thousand men and ask if they should send the people home. Jesus responds, "You give them something to eat." He then blesses the food.

At that moment, the fish and five loaves become food to supernaturally feed not only five thousand men, but women and children there as well – with twelve baskets leftover!

Many of us have looked at our talents or the arts expansion we desire for our church, city, and for the nations strictly through the lens of how far the world has gone. We are forgetting about the multiplication of the loaves and the fish. We need to see how the *supernatural influence of heaven* can breathe life into it! We have learned to trust in what we *know,* not in *Whose we are.* This makes all the difference in the world. We are the ones called to influence the arts realm of society. We carry the very voice of heaven, because we have communion with the Father. We can have supernatural wisdom to see the arts transform and shift culture so that the kingdoms of this world become the Kingdom of our God!

Here is a testimony about how the supernatural anointing from heaven can impact others. I had an art exhibit of portraits I had painted, along with many other pieces created by students from our Bethel School of Supernatural Ministry at City Hall in Redding, California. As people were looking at the various pieces I had done, they would come up to me and comment on the feeling and emotions of the piece. They were getting so touched that many were crying and felt like they had an encounter as they looked into the eyes of the faces I had painted on the canvas. This gave me a platform to talk to them about why I painted them and what these people represented. Many of them were visibly touched, while some even got healed by experiencing God! This is the power of painting in God's presence from heaven's perspective and releasing it in your art expression. There are no *ordinary* expressions of creativity when you sing, dance, paint, and act from heaven towards earth!

So what does it look like to create from our position in "heavenly places with Christ"? How do we cultivate an intimate connection with God that allows *His* creativity to flow through *us*? Here are some thoughts from Francesco Sideli, one of my arts interns in Bethel School of Supernatural Ministry, about his fellowship with God in the realms of the creative:

> *Creative partnership is about relationship. Relationship is about intimacy, and intimacy is about communication.*

Intimacy with God is about communication – when God speaks we listen, and when we speak He hears us. For me creative partnership is about *relationship*. Relationship is about *intimacy,* and intimacy is about *communication*. John 5:19-20 says that Jesus only did what He saw His Father doing, and that the Father *loves* the Son and *shows Him all that He does*. This is such a picture of relationship and communication. Some have asked me, "How are you confident that you are hearing God so clearly as to do something so outside-the-box and unconventional as healing people as they pass through a chalk drawing?" My reply is *relationship*. I want to be known as someone who listens and knows God's ways, His presence, and His voice.

One day, after being inspired by the creativity of other cultures, I felt the Lord leading me to use chalk to draw shapes on the sidewalk and that as people stepped into these drawings, they would

encounter His presence and be healed. If the medicine men of different cultures can draw pictures on the ground for the healing of the sick, then surely we can see the Father's heart released in *far* greater measure through partnership with the Holy Spirit! So I went out to a local grocery store in our community and simply drew a square on the ground in chalk. I saw a man walking by and saw that he had pain in his leg so I simply told him that if he stepped into this square that he would be healed. He gave me a strange look at the start but then stepped into the square, and immediately began to experience the presence of God! He felt fiery warmth all over his body when he was inside the lines, and then it would leave when he stepped outside of them. He was absolutely amazed and discovered that he was healed as all the pain left his body! This is such a beautiful example of how God meets us as we step out with faith into new realms of creativity – this act of faith releases His heart as we partner creatively with the Holy Spirit . I love it when people hear God, act on it, and see God do astonishing things! This experience had such impact because it continually instills an awe and a wonder of God. *Every time* God reveals another facet of Himself, the living creatures and elders fall down and worship God! A key to creativity is *paying attention* to when God reveals another facet of His nature and character. In order to grow in creativity we must simply purpose ourselves to *continually be in awe of God.*

Another amazing experience in my journey of coming to a deeper understanding of creative partnership with God was during a time of ministry at a church called Living Hope. In the morning I prayed over four drawings I had done and received four words of knowledge to go with them for specific people. I wanted to give out drawings on paper that were saturated with the presence of God and see if people would get healed by simply holding onto the drawings, just like when Paul laid his hands on the handkerchiefs in Acts. The first drawing went to a woman named Susan who had neck and back pain. I had her come up to the front of the

> *A key to creativity is paying attention to when God reveals another facet of His nature.*

room and gave her a drawing. Afterwards, her neck felt the same but then I laid hands on her and prayed, and then she was able to move around her head with no stiffness or pain. The second was for a man named Robert with a joint problem in his ankle. He came up limping and took the drawing I had done of a tire. After he had received the drawing and had been holding onto it for a few minutes, he said it felt like someone had put a heat pack around his ankle and the pain left! By the end of the service he was walking around with no limp. Another woman named Monica was going to get hip replacement surgery, so I gave her a drawing and when I checked back at the end of the service she said that she had *no more pain* in her hip! Finally, my fourth drawing went to a woman named Peggy. She came into the service with neck and shoulder pain, so bad that earlier in the day she had been *crying*, asking God for it to stop. After I gave her the drawing, she held on to it for the entire service, and at the end she was completely healed! Because I did what *He* was doing, His power and love were released into the lives of these four people and Peggy experienced a greater reality of the Father's love!

"Heavenly Places" Exercise:

Take a moment and ask God to reveal the power of living *from heaven,* by being seated in heavenly places with Him in the eternal Kingdom of His presence. Ephesians 2:6 says that God *has* seated us in heavenly places. This is present tense, which means that it is possible now. Many of us understand how God operates in the physical realm, but we have not become familiar with living in the supernatural realm of heaven. And yet, the majority of those who walked with God had heavenly encounters and visions. Why isn't this common today? We live such busy lives, which are filled with so many sounds and external information that we can't really get in touch with heavenly realms. Jesus showed us that when He dwelt with the Father as He spent time alone, He was building a deposit not in the physical, but the supernatural realm. There will be activation exercises, which help us get in touch with *being in heavenly realms,*" which can make our relationship with Him much more tangible and real. The arts can become a way of expressing what God is doing from these other realms, which brings *"heaven to earth."* Take a risk, and give God your two fish and five loaves as described in this chapter, and let God multiply them supernaturally to transform others around you – especially yourself!

Here is an exercise to help you begin to see past the natural and communicate with God for a supernatural vision of what you carry. Get alone and find a place where you can relax. Read this portion, and let God begin to take you up into the heavenly realms.

Imagine everything else in your life colored by the lens of heaven's filter. As you step in, there is no sickness, anxiety, or fear – everything in your life is transformed by His touch. Take a few moments and spend time with God, letting Him show you what heaven is like. Ask Him to show you your gifts and dreams, maybe things that you have kept hidden, because you didn't know they were significant to God. Ask God what He thinks of your dreams and see what He says.

After this exercise, take some time and write or draw what God said and what you saw. In this exercise, you are learning to bring heaven down to earth!

ACTIVATION EXERCISE:

God not only wants to reveal a heavenly mindset about you, but He also wants to show you a heavenly mindset for others. Get into a quiet place, where you can be alone with God and will be uninterrupted. Ask God to show you someone in your life who needs a blessing. Take time, and ask the Holy Spirit to reveal an image, song, message, dance, art piece, or creative expression that would bless them through partnering your creativity with the Holy Spirit's. Ask Him, "Father, what is in Your heart for this person? What do You love about them? What promises or encouragement do You want to declare over them?" Now take time and create it here on this page and then actually make a card for that person with what God showed you. Share with this person what you created and ask them what it means to them. See your heavenly encounters transform others before your very eyes and record the testimony!

GROUP EXERCISE:

You will need a couple of blank pieces of paper, a pencil, sharpener, colored pencils or oil pastels for each person before you begin. Gather in a group, and begin by having each person share what gifts they feel they have. Then have the people in the group break into twos and share about what dreams they see for each other. Speak *life* and encouragement into each person, declaring what *God* says about them! Then pair up and ask the Lord for a picture, song, or drama, which ties into their destiny, and either write it down or create the picture. I usually allow for about 3-5 minutes during which everyone is quiet and people are hearing from God *before* they begin to create. After you are done, share with the other person what God shared with you and ask for feedback.

On another occasion, ask the Holy Spirit for a person who needs to know His love. It could be someone who needs healing or encouragement. Ask the Father what you need to draw on a card to release God's prophetic word over their life. When you've completed the picture, write the prophetic meaning of it on the back. As a group, pray together over the drawings and ask God to soak them in His presence! Then connect as a group the following week and share about what happened when you gave out your art to other people! God is delighted when we partner with Him so *expect* good things to happen!

Take time now and record the testimony of what happened in this group exercise.

EXERCISE FOR CHILDREN:

You will need blank paper, colored pencils, pencils, sharpener, and crayons for this exercise. Have the children lie down and close their eyes. Ask Jesus to take them to heaven (explain what heaven is like and how wonderful it is so that they have a grid for it from a biblical framework.) Wait 3 minutes. Now ask Jesus to show them what gifts He has given each one of them. Wait 3 minutes. After that, have them sit up and draw what gifts God has given them. They then can share with the group about their picture as you or other peers share encouraging words as well. This is a time for them to value what God has given them and for others to see who they are without fear or comparison! Make sure *all* are affirmed!

Write down the testimonies from the children here:

IMPORTANT KEY:

As you do all of the exercises, remember that prophetic arts are always encouraging and uplifting. Make sure that people's pictures and words bring people closer to God and reveal biblical understanding about His nature.

CHAPTER 2
You Were Born to Create

Creation *Artist:* Katie Nelson

Everything that is innately in God's nature can be found in ours. Once we see that our ability to create comes from God, then we can begin to embrace our nature and His great design.

RENAISSANCE AWAKENING

He stood, staring at the deep blackness, listening only to the droning, reverberating of His breath hovering over the stillness. It was the most anticipation-filled moment of eternity. All of heaven stood still, waiting on the edge, breathless, eyes unblinking as the Creator stood over the darkness like a canvas, like a palette upon which the visions in His mind and His heart would be displayed.

Before the morning stars sang together, before the universe began, there, in the darkness, "Light!" A song was begun as the sound of "Let there be!" began to reverberate, its very resonance creating things once unknown. And there was. First light, then sky, stretching out as far as the eye could see. "Let the waters below the heavens be gathered into one place, and let the dry land appear!" continued the chorus, and something like the breath of wind and hands on a potter's wheel began to form the earth and separate the water into oceans, lakes, and rivers, and the dry ground into mountains, valleys, and plains. Then a second verse, and life began to appear. Trees, grass, fruit, springing forth from the newly formed earth, every vine, every branch adding a richness to the song. Lights appeared in the sky and the voice of the stars were added to the symphony. And with each "Let there be!" from the Conductor, another voice was added. Now cuing in the sound of a great humpback whale in the sea, an eagle in the sky, and the roar of a lion on the earth. The canvas of earth, sea, and sky now seemed full with such wonderful creations, but the creator had just begun.

For the first time since the song began, the Creator turned towards heaven and with a twinkle in His eye that shone from the very desires of His soul, He said "Let Us make man in Our own image." Calling the angels to gather close, the Father of earth and sky began to form the children of His heart. Never had such care and thought come out of Him as it did that day. This was to be His masterpiece, the very epitome of creation. The image now formed, He breathed His breath, and they awoke! His very self, His very image ingrained forever in the expressions of His children with His very life flowing through them. Each one representing a different facet of His face. Each one with different expressions of His character, awakened by the sound of His voice.

But the creation did not stop here, for in the very essence of creating children in His image, the Creator established billions of creators on this earth. And as His breath, as His song began creation, creating light, creating life, so the very children of His breath now breathe, perpetuating life. This is our breath, this is our song, "Awake!" to call life from the dead and light into darkness.

A new renaissance is coming, a new shift from darkness to light. Like the prince awakened Sleeping Beauty in the top of the castle, our kisses, our expressions of love to the Father will awaken His children and perpetuate His creation to new realms of life and beauty. There are medical secrets waiting to be discovered, inventions yet to be invented, methods of education waiting to be formed and stories yet to be written. There are business strategies yet unknown and political leaders waiting to be counseled with the wisdom of heaven. There are children longing to be fathered, and a church waiting to be revived. It's time for a Renaissance Awakening."
(Written by Tiffany Christensen)

If God's first act was to create the heavens and the earth as well as man in His image, then we must see *creativity* as one of the fundamental characteristics in His nature and in ours! In Genesis 1 and 2, God's response to whatever He created was "and it was good." What does this reveal about God the Father and His pleasure in His creation? In Genesis 1:27, He then created man and woman *in His own image*. This means that *everything* that is innately in God's nature can be found in *ours*. Once we see that our ability to create comes from God, then we can begin to embrace our nature and His great design, which is given to each human being. In Genesis 2:19, we see man's first assignment from God is to name the animals.

> *He is passionately committed to revealing to you that EVERYTHING you create is beautiful to Him!*

As Adam named the animals, his words were shaping their characteristics and destiny! It is so interesting to me that God would choose Adam to do this. Instead of doing it Himself, He wanted to *partner* with Adam's unique creativity in naming the animals so Adam could be part of His creative design in filling the whole world with His glory! God loves partnership. Just look at the Trinity! They never stop honoring each other! Think about what this means for us! In the very same way, you were designed by God to create. Father God desired this from the beginning of time, and chose you in love before the foundations of the world (Romans 8). Everything you create in His presence *is good*, because it carries the backing of God's creative nature within us!

Now, there are probably questions entering your mind right now. You may be thinking, "Wait. Really? I was *born to create?*" Yes, creativity is an essential part of your being because as a son or daughter of God, you have your Father's creative, life-giving DNA! However, that beautiful truth about your creative identity in the Father has most likely been challenged at some point in your life! Many of us, from the time we were small children, were told by others whether or not we were one of those "special creative types," and if our parents, teachers, or peers deemed that we didn't fit that mold, then creative expression was immediately removed from our identity as an individual. If only we realized how powerful and significant those declarations can be, that in one moment, a person could be made to believe the lie that they have no proper place in the realm of the creative! It's the very same ploy that the enemy used with Adam and Eve in the garden when he asked, "Did God *really* say...?" We can also see from the beginning of creation that the enemy has never been happy about our fellowship with God. He is so threatened when the sons and daughters of God walk in the fullness of their creative identity in the Father and operate out of the authority that they have been given by Him! The *truth* from the heart of your heavenly Father is that *every one* of His children is creative, including you! If anyone has ever disqualified you from creative expression, then the Father is eagerly waiting to show you all the incredible gifts He wants to give you and the creative ways He wants to partner with you! If you've ever believed the lie that you can't create anything of worth or beauty, He is passionately committed to revealing to you that *everything* you create is beautiful to Him!

If we are to step forward and begin to embrace our creative identity in God, it is important that we let God uncover the lies that we have believed about who we are, and then invite Him to speak His truth in love! It is His truth that launches us into freedom so the purpose of the following section is to help reveal the lies and break off the fear so that you may boldly walk in who the Father has called you to be! Many of us have come from backgrounds where

we have been criticized for creating things different than others. Others have judged what we have created based on expectations of what is good that haven't come from the Father of all, but from the condemning father of lies. We need to get back our sense of individuality and enjoyment in creating, because we are made in His image and no two people were meant to create the same thing. Some of us are so scared of what people think if we create or color outside the lines that we live in a box of conformity, never enjoying our God-given creativity and uniqueness. It is time for God to shatter the lies that surround your creativity as a human being and for you to know that God loves what you create, because it comes from you and not because it is perfect! Here is a test which helps you understand if you are living in freedom as you create.

INSTRUCTIONS:

Read each question. Then from the top of the list choose which number rating best describes your response.
Place the number of the term in the blank space to the left of the question.

1	2	3	4	5	6
Always	Very Often	Often	Sometimes	Rarely	Never

_____ Do you feel pressured to "perform well" at the risk of displeasing God or others?

_____ Do you talk negatively to yourself when you are creating something (drawing, painting, cooking, singing, etc)?

_____ Do you compare yourself to others when you create?

_____ When you think of yourself, do you tend to look at your limitations not your assets?

_____ Because of fear, do you just not try new things?

_____ Do you put yourself down, so that you don't try anything new or venture into things you've never experienced?

_____ Do you have anxiety when it comes to creating?

_____ Do you feel like you don't measure up to the expectations of others and yourself?

_____ Do you feel like your work is just not good enough to show others?

_____ Do you feel like you have to do everything perfect?

_____ Do you feel worthless or crushed inside, or get angry when you are criticized?

 A low score on many of the answers indicates that God wants to set you free in your heart so that you can start to believe in who you are!

 It is time to break off all comparisons, lies and disqualifications and begin to see ourselves through the eyes of our Father in heaven!

DECLARATIONS:

Say this out loud and declare it with authority:

I am creative! I am seated with Christ in heavenly realms and create things because He enjoys me! Everything I create is good and has value to God. I break off any lie or doubt that I can create good things that bring God and others pleasure. I break off the lie that I have to be perfect and can't make mistakes! I break off comparison and will rejoice in what I create and in the creative expressions of others! I break off all fear and will rest and create from His perfect love! I declare that I am free to explore and discover with childlike faith. My Father delights in *all* that I create and proudly displays it on His fridge, because I am His son or daughter – made in His image. I can color *outside* the lines! I am *not* bound by what I know - I can create outside of my understanding because I have the mind of Christ and therefore my imagination is *sanctified* in Him!

STEPPING INTO YOUR FREEDOM:

Individual Exercise:

Now that you are free, it is time to create! Get a piece of paper and any kind of pen, marker, or colored pencil. Next, close your eyes. That's right, you heard me! Close your eyes, put your hand on your paper and say out loud, "I free myself to trust that God will flow through me and create. Everything He creates through me, I will bless, because I trust in Him." Now begin to let God draw with you as you move your writing device! Be free! It is time for you to color outside the lines and be creative! Keep doing it for 5-7 minutes. After you are done, look at the paper - Do you see anything in it? Any shapes or forms? Part of what you are learning to do is to see beyond the literal, and look into the supernatural. Ask God what He wants to reveal to you through what you've created. Make sure you *always* sign your name on what you create! Trisha Wheeler, an art teacher in our school of ministry here at Bethel has seen so many people break free of lies just by doing this exercise!

Feedback after this exercise: Make sure after you draw with your eyes closed, that you learn to evaluate your art based upon God's Presence rather than performance type thinking. So realizing your ability to be free to draw being led by the Spirit will help you begin to trust Him rather than ability alone. Our starting point matters. First, we must become a human "being" made for His glory and pleasure before we can become a human doing. If you trust in His pleasure over your life, then you can move on to partnering the Holy Spirit with your God-given creative abilities.

PROPHETIC ART:

Group Exercise:

Have everyone in the group take the test (above) and then break into twos and share about their answers. If any of them felt troubled by their answers, take some time and let God break off any lies that they have been believing and replace those lies with the truth. Share the biblical truth that is the opposite of the lie. Now give them paper and colored pencils. Have them close their eyes while holding the pencil. Let them now feel Jesus put His hand on them and feel His pleasure over them. Then, have them begin to *draw with their eyes still closed*. Let them draw for 3-5 minutes. Ask them how it felt to take that risk and then have them share their work with one other person in the group. Have them ask the other person what they see prophetically in the picture. Make sure that they sign their work and encourage them in their first endeavor of drawing with Jesus blindfolded!

Write out what God showed you about this exercise and what you learned about yourself!

Exercise of Freedom for Children:

You will need pencils and paper for the children. Tell them that the Holy Spirit wants to draw with them, that He wants to free them to not think about what they will create, but just to let go and trust that He will draw with them! Then blindfold the children and let them draw! When they are done, talk about their pictures and how God loves to create with them. See if you can find some shapes and some designs that you can all comment on, then have them sign their work by writing their name and then write the Holy Spirit underneath of their signature! We are learning it's all about being in His presence! Write down here the testimonies about what God showed the children as they created.

ENCOUNTERING GOD'S LOVE:

Individual Exercise:

Many of us have never really taken the time to "hear" from God on what He loves about us. Many of us have tried to earn God's love or just haven't really believed how much God wants to communicate His love to us! This art exercise frees you to hear and then create something that communicates God's love for you! Set aside some time in which you're sure you will not be interrupted. Now just relax in God's presence. You may want to turn on some soft, instrumental music. Now focus your attention on Jesus - on His face, His goodness towards you and picture Him standing in front of you. As you look at Jesus, ask Him what He loves about you. Don't doubt what He says. Thank Jesus and then open up your eyes. Now comes the fun part. Draw whatever comes to mind from what God shared with you! It could be an image, you and Jesus together, symbols, words, different shades of colors, whatever it is – draw it and then sign your name at the bottom. Some of you might have heard God singing a song over you or experienced another creative expression. Write down what God revealed to you.

Draw what you see below:

Group Exercise:

Go on a corporate time with some instrumental soaking music where you do the above individual exercise as a group. After you have drawn your picture from your experience, share your picture and your experience within the group! Ask the group about what they saw in the picture as well and write it down.

Exercise for Children:

Have all the children lie down, making sure that no one is touching anyone so that they won't get disturbed. Turn on some soft music. Have them picture Jesus standing in front of them, and then have them ask out loud together, "Jesus, what do you love about me?" Wait around 5 minutes for God to respond. Then have the children draw a picture about how God loves them! Give them 15 minutes. You can have blank paper, markers, crayons, colored pencils for them to use. As they are drawing, go around the room and make sure that everyone has a picture. If not, pray for them or prophesy about what you sense God loves about them. This will help them. Many times I tell people to just start drawing and then it will come to them. After they are all done, have them share about what God showed them. Don't forget at the end for them to write on the page "What God loves about me" and have them sign their work. Tell them to share with their parents when they get home. Write testimonies about what happened with this exercise with the children here:

CHAPTER 3
Calling Out the Gold in Others

Love and Power *Artist:* Melissa Cordell

As people receive a picture about who they are and how much God loves

them, their countenance completely changes and hope is birthed!

I remember the first time I began to understand how the arts could prophesy God's heart for someone. My husband, Kevin and I were ministering at a church in Olympia, Washington. We began to paint during the worship time. As the three or four artists began to paint, I asked them to prophesy through their paintings what they felt the Holy Spirit was saying to the congregation. After worship, they each presented their painting, and shared the prophetic meaning of the piece they had created. As they did it, you could see light bulbs turning on inside of people! They understood a message from God, not just through the spoken word, but through the visual arts. People were so touched that many people asked if they could take these paintings home! What was even more interesting is that the BSSM students on our team who had painted the pictures *weren't artists at all*. They took a risk and God used them to change lives!

Soon after seeing God move so powerfully, I took this concept and began to envision how we could use it out in the marketplace. We now take pencils, paper, colored pencils, and pastels with clipboards and set up at different places where we know we can have social connection with people. I have taken teams to the malls, parks, hospitals, shopping areas, coffee shops - everywhere! As people receive a picture about who they are and how much God loves them, their countenance completely changes and hope is birthed inside of them! Everyone loves to receive a free art piece. It doesn't matter the age, nationality, socio-economic background, or religion. Art crosses all of these barriers! It doesn't matter how much experience you have in art either; it just takes you sitting down, asking the Holy Spirit what He loves about someone and drawing what you see. Our prophetic arts teams now consist of nearly 300 Bethel School of Supernatural Ministrystudents who are empowered to touch people through the arts every Thursday afternoon.

> *It doesn't matter how much experience you have in art - it just takes you sitting down, asking the Holy Spirit what He loves about someone and drawing what you see.*

During one of these times when we went out in the community, a 40-year-old student from our school who had *never* done art before drew a picture of a stick-figure man standing next to a cross. As the student gave it to someone he met, the person was so instantaneously touched, that he was *radically* saved and set free from oppression! God will touch people through pictures you create in partnership with the Holy Spirit. You can either draw a picture with the recipient sitting next to you or you can draw the picture beforehand and then ask God to show you who it's for! For instance, I had drawn a picture as I was praying one morning. All I used was a pen and white copy paper. I drew a mountain with someone walking up it. On the card I wrote, "You can climb to the top of any mountain..." On the inside, I continued the message, "...because God is with you and He will never leave you or forsake you." I then stuck it in my purse, and went about my day. My husband and I were going out to dinner, and as we were about to enter the restaurant, I felt in my purse and realized I had forgotten about the card. As we walked into the restaurant, I saw a woman sitting on the curb with two other women consoling her. I knew in my spirit that if she came in the restaurant, the card was for her. Sure enough, she came inside so I left the table where I was sitting to speak to her. As I got closer, I could hear her telling the manager that she was going home, so I waited in front of the door. As she approached, I told her that I had made a card earlier that day for her - even though I didn't know her. I read the card

and showed it to her. The minute I finished, she screamed and fell into my arms, while the whole restaurant stared in shock! I asked her what it meant. She said that her ex-boyfriend had just come into the restaurant 20 minutes prior. This was so painful because they had broken up months before and she was still deeply in love with him. When he came in, he was accompanied by a woman who was now his fiancé! She was so heartbroken. I told her- "Isn't it interesting that I put on the card that God will never leave you or forsake you? Your boyfriend left, but God promises to always be with you." Through tears of hope, she let me pray for her and as she left, she was changed. This is the power of prophetic art! It changes people!

I teach people in the Bethel School of Supernatural Ministry as well as when I travel around the world about the gift of prophetic art and how partnering this with the prophetic can change lives. So many people actually frame the artwork they receive or keep it for life. It's the gift that keeps on prophesying and touching lives. Every time they see it, the memory comes back and instills life into them.

With that testimony in your heart, read the following section about calling out the gold in others through prophetic interpretive portraits (written by Amy Rochelle Watson):

There is something profound that happens when a person receives a prophetic portrait that declares to them who they are. Pictures can speak to us in places that words just can't. They stay in our minds, and often on our walls, constantly speaking to us as reminders.

People need to hear God speak to them in new ways. Ways that creatively demonstrate His unique care for them. We live in a world saturated with words that often have been watered down in meaning. While the strength and meaning of words can be dismissed, prophetic portraits (images that call out a person's destiny) carry great impact as fresh ways of calling out the gold in others. They have a poignancy to them that can be hard to get with mere words. God often speaks to us through pictures when we ask Him to give us His heart for another person. He leans down and draws an image on the chalkboard of our imaginations. These images can take many forms, from mountains and flower beds to classic cars. When we draw these images for people, we are presenting to them the message just as God delivered it to us – in the form of a picture.

Sometimes we instantly know in our spirits exactly what this image means and other times it is something we have to press into. But these pictures always come rich in layers of meaning. Instead of limiting the message to what we can define with words, prophetic portraits create the opportunity for messages to be released that we could not have known ourselves. Often we will give the layer of meaning God has shown us, and discover what seems a simple symbol to us will mean a great deal more to the person who is receiving it.

It is the power of pictures to continue speaking that makes them stand out from words. While words often give one message and one only, pictures continue to speak revelation as God's spirit makes them alive to a person. In giving someone a prophetic portrait we are actually opening up a

door for God to speak directly into their lives where they begin to get revelations of their own. If we encourage people to let God continue speaking to them through the art piece, then we are not only giving them a word from God, but we are training them to hear His voice for themselves.

Prophetic portraits also have an ability to speak beyond walls that many people have built in their lives. Perhaps they are walls of familiarity that dismiss the strength and meaning in a prophetic word. Sometimes they are walls erected to keep other people from speaking into places where they feel most vulnerable. Pictures are non-threatening ways to bring a message that will go deep and they are often readily accepted where words are not. Often in cases of street ministry, it is simply easier to approach people with prophetic art in hand. A drawing, no matter how simple, can be a tool to open locked doors.

Nothing impacts a person more than seeing himself the way God does. There is a grace that comes into our lives when He speaks to us about who we are. It not only shapes our identity but releases us to walk in it. By calling out the gold in others, we are literally drawing mirrors and holding them up for people to see who they are in God's eyes. As people begin to see themselves as He does, they receive the tools they need to overcome obstacles. This is why prophetic portraits always aim to show others who they are in light of God's grace. It is the gold God has placed within people that will call them into who they were made to me. The heart of every prophetic art piece should be to communicate the very personal love of God. We get the privilege of being the ones to hold the mirror. The ones to carry the messages God longs to release to those around us.

EXERCISE IN PROPHETIC ART:

So, here's how you do a prophetic art piece! First, let God's presence fill you and just rest in Him. You are partnering with heaven and the Creator of the universe has a message to bring through you right now! Start by practicing this with someone you know (a family member or friend) and then your next time, try it with someone you don't know. Simply start by asking them if you can do an art piece or card for them. Explain that you are just learning how to do art and it will only take a few moments. Now comes the fun part. Ask the Holy Spirit to tell you something He loves about that person! It is important to be aware that all prophecy is to encourage, comfort, and exhort others I Cor. 14:3). Make sure that your words and picture build them up. If it is scary, fearful, or foreboding, don't draw it. This is why we focus on the good things God wants to share, which bring them hope. So, as you ask the Holy Spirit, filter it through I Corinthians 13 to make sure that it is loving and Philippians 4 to make sure that it is something uplifting. Then, begin to draw whatever comes to mind! What shapes do you see? What colors? What words come to mind? The Holy Spirit may bring to mind a Scripture, a promise or a song as well! As you draw them, engage the person in conversation and ask them about the dreams in their heart and what's happening in their life. As you continue to draw, ask God for more downloads about them and add it to your picture.

After you finish the piece, explain to them what you drew and what you feel it means. Then ask them for feedback. You will be so surprised at how accurate your drawing is! Many people open up and you are able to

share the Lord with them, pray for healing, or radically bless them with His love! Whatever happens, bless them and see if you can pray for them! A typical drawing for a friend can take up to 20-30 minutes. For a person out in the community, you need to be sensitive to their time constraints and ask how long they have. Many times I have finished a picture in 5 minutes, while at other times, they have wanted to engage in talking and I have spent up to half an hour with them. As you finish telling them the interpretation/meaning of the piece and they have given you feedback, now is the time when you need to ask the Holy Spirit what He wants to do next. Many times, I have prayed with people and they have given their life to Christ or they have been healed. I *always bless* each person as they leave and thank them for their time. At Bethel, we believe that every encounter we have with someone is a love encounter. Love them with your eyes, smile, and heart. People in the community are so longing to be noticed and affirmed.

After you have practiced on people you know, then take it out into the marketplace and do it for a stranger. Make sure you ask them what it means to them so that you can see if you have drawn anything significant from their life. Write down the testimonies. You will be amazed by how God works through you!

In order to do this prophetic art piece, you can use a clipboard with a sketch pad, colored pencils, oil pastels, or markers. Many of you who know how to do watercolor or acrylic may want to use these mediums as well. Just make sure that you have the right paper and have all the supplies necessary for this as well. If you use dry media, it is easier to transport and doesn't take any time to dry, but if you are able to use these in a public place with water media- this can be fun and more versatile as well.

Prophetic Art Piece: Immediate Activation

Ask the Holy Spirit to give you a picture right now for someone close to you. It could be a close friend, co-worker, or roommate.

Draw the picture in your manual here and show it to them, giving them the interpretation of your work. Ask for feedback on the picture and write down what they said. You can also copy what you have drawn here on another piece of paper and then give it to them so that they can take it home with them.

Draw two to three pictures for both those you know and those you don't. Write down the testimonies about what happened and what they thought of your work and interpretation. As you do more and more, you become familiar with talking as you draw and just the way it works. Remember, this is something that may take time, but the more you do it, the freer you will be and then you can continue to do it wherever you go! I have done it during worship services, in the car, in the morning as I pray, and when there are parties.

Prophetic Art:

TESTIMONIES:

GROUP EXERCISE:

Pass out blank pieces of paper to everyone with colored pencils, pencils, and oil pastels. Pair up everybody within the group, and have them ask the Holy Spirit what He loves about their partner. Sometimes, I have them touch the person so they can even sense more things. Have them wait 3 minutes for downloads from the Holy Spirit on what to create for that specific person. After they do this, begin to draw what you see. Again, be looking for shapes, messages, symbols, figures, and anything else that comes to mind (see prophetic color meanings in back index). Many times we think what we are drawing or seeing might not be relevant or that it's weird, but trust what God shows you even if it doesn't make sense. I usually give people around 10-15 minutes to draw. After they are done, they can write the message or interpretation on the back. Next, exchange the art piece and tell each other the meaning of what was drawn and ask for feedback on it. After everyone has shared, I have people come up and share how their art piece touched them. You will be amazed at the response!

After this exercise, it is time for you to take this out into the community. So you can either draw a piece for someone you will meet and then you can go out in a group of two or three to find the person (See Prophetic Art

Treasure Hunt Sheet in index) or you can gather up a clipboard with paper and colored pencils, sharpener, pencil, and oil pastels and go to a place where people are sitting down or walking by. If it is cold and rainy, pick a place like a mall or food court area to set up your stuff. If it is warm and nice, pick a place like a park with a playground or a place where people are walking about. I approach people I meet by smiling, saying my name and telling them that we are just starting out learning to draw pictures for people and ask if they have time to sit down as we draw a piece for them or if they have time to receive one if I have one in my hand. I let them know that it will be a picture that represents who they are in a symbolic or literal way. At this time, if I have people who are just starting out, I will let the people know that so that it puts the people drawing at ease. I usually smile, shake their hand, and speak about something meaningful to them as I make contact. I either mention the weather, the season we are in or holiday, what they are wearing, or something relevant to their station or age in life. This breaks the ice and builds rapport. I also avoid Christian jargon, which they might not be accustomed to. The more comfortable and at peace you are with yourself as you just bask in His Presence, the more the conversation will flow naturally. Also, give it time! I didn't get this right the first time I went out! God really doesn't care if you get it right, just that you love those you meet. If you go out as a group, it is going to be easier to do because you can play off of each other's strengths as you reach out to people. This will give you more courage and more understanding. Also, people love to receive things. I also let them know that it is free, and that we are not asking for anything; we just want to encourage and bless them!

Note: I have learned to break people up into mixed male and female groups if at all possible when we go out. For instance, it can be intimidating to go up to a woman if you are in an all male group. Also, it can be awkward for a man to be approached by an all female group. If you can't do this, don't let it stop you, but just be aware if you have the option available, it usually works out better if you have both men and women in your group. I also bend down if I am speaking to a child, so that they feel honored as well. These little things are very important as we build rapport and honor in our community. We also honor and respect businesses and restaurants by not stopping the flow of business with our different arts. If a manager does not want you there, respect their wishes, and honor their request. We are partnering with the city and the more we honor others, the more honor will be given to God and His name, which we serve!

SEEING IN THE SPIRIT:

As I have trained people over the years, I have an invaluable tip, which will really release powerful encounters of the supernatural. Many of us have never been trained on how "to see" others in the Spirit. I always look at what God is doing in and through the person as I am talking or giving the person an art piece. I look for signs of their heart opening by the way they look at me, their facial expressions, tears in their eyes, emotions in their voice, looking away, and visibly being moved by the Spirit. These are all indications for you to continue to minister to them. Take advantage if the door is open. Ask if they have ever felt God's presence and release it on them. Ask if they need prayer for healing in their body (you may receive a word of knowledge). Share a personal testimony about healing or how God has touched you. Ask them questions to find out what is going on inside. These are the *keys to breakthrough* in the arts. God is opening up doors by softening their hearts, so don't be afraid to take it further and see what God is doing through your picture. I always ask: *What does this picture mean to you?*

EXERCISE FOR CHILDREN:

Children love to draw for other people! Explain that they can hear from God and that it must be positive, encouraging, and comforting. Then pair them up with someone and have them pray about what God loves about them and then begin to draw. After about 10 minutes, have them share their pictures with each other. Then let the person give them feedback. You can do this either one-on-one or in a group by pairing up the children. You can also take children with you as you go out and do prophetic art pictures for people. They absolutely love it and people love to get an art piece from a child! You can also do this in a Sunday School class for the children to encourage and bring out the gold in their peers. They can also do this for their parents as well or family members.

TESTIMONIES:

CHAPTER 4
Intercession Through the Prophetic Arts

Doorway to the Presence *Photographer:* Kristen D'Arpa

We can partner with God to touch situations and impart healing and transformation - even if we are miles apart from each other! The Spirit is not bound by human limitations and the Arts release healing to many situations around the globe.

The arts can be integrated into our intercession for a person, a situation, or a geographical location that is in crisis. All of us have people that we love who are going through situations that need our prayers. The picture of hope that we draw or song of life that we sing can change their situation and release freedom and healing! Many people can't express their pain and we feel inadequate when we try to comfort them through mere words. Pictures can bring hope and healing to others who can't verbally process what is going on inside. For instance, when I had a severe brain injury, they had to shave off half of my hair to perform the operation. I was in critical condition and tremendously in need of healing and restoration. My prophetic arts students made a collage of me with a full head of hair and had declarative words about my whole body being restored. This brought not only hope but healing to my heart! The impact of their drawing was incredible! Within 3 weeks, I was back to work when it usually takes at least 6 months of recovery! Also, the small children in Sunday school took fleece material and made a "supernatural blanket." They drew prophetic pictures and colors releasing healing. I kept that blanket on me during my recovery! As we trust that God will give us a picture or message for someone that can change their situation, we can uniquely speak into situations of pain, releasing love and declaring God's goodness! I still have that blanket and it reminds me of the miracle God did in restoring me back to full health! It is a living testimony for me of God's goodness!

> *Pictures can bring hope and healing to others who can't verbally process what is going on inside.*

Missions Trips

We also saw the arts used for intercession and healing in an incredible way while we were on a recent ministry trip to Rwanda. The lives of the students we invested into had been *devastated* by the terrors of the genocide 15 years ago. Many of them had seen their families killed before their eyes, some were buried alive or experienced trauma beyond what you can imagine. But through the arts, they were not only able to find a voice to express the pain in their hearts but their creative expression became an open door to encountering their heavenly Father, as He poured out His love and healing into their brokenness. The most incredible thing was that these precious students began to understand that their personal healing was really intercession, paving the way for their *entire nation* to step into the freedom and restoration of God's redeeming love!

Another great testimony about intercession through the arts happened when I was in Tepic, Mexico, on a mission trip. My friend, Donna Taylor, had dislocated her knee while ministering in a Mexican Indian village. During the time of the accident, her daughter back home felt led to draw a picture of an Indian in intercession for her mother's trip – even though she was unaware of the situation. The following day, Donna refused to stay in bed, but wanted to be with the team as we were opening the door to the church that would be planted in that city. As she interceded with her knee bandaged up, miraculous things happened in that little village! People were healed, saved, and delivered! It was incredible as well because this village was an Indian village in Mexico, which her daughter was unaware of! When Donna came home and met with her daughter, she showed her the picture she had drawn. It looked exactly like the people in that village! We can partner with God to touch situations and impart healing and transformation even if we are miles apart from each other! The Spirit is not bound by human limitations, and the arts release healing to many situations around the globe. This reminds me of the story of the centurion in the Gospels,

who believed that if God just spoke the word, his servant would be healed! We are now seeing that if you just draw the word, people will be healed!

Arts Can Shift Nature!

We are training children as young as 3 years of age to draw pictures about what God is saying and what God is doing in intercession. One evening during a church service, some of our children's ministry team were training children in creating some prophetic art. As all the children were drawing, one little girl in particular drew a picture of a swirl. When asked about the meaning of her picture, she simply replied ,"Oh, it's an earthquake." The children's workers were curious about this and felt the Holy Spirit was doing something so they asked the girl if she felt a specific location connected to the earthquake. Again, she simply and confidently replied, " In Mexico." As soon as they heard that, they decided to gather the children together and pray protection over Mexico! They so strongly felt the presence of the Holy Spirit as the children prayed! Sure enough, they did some research the following day and discovered that there had been a 2.5 earthquake in Mexico at 4 AM, just *hours* after they had prayed together!

During a worship service at one of our large Bethel gatherings in 2006, Karyn Stevens painted a scene of a huge wave with a wall or building obstructing the water from penetrating it. After she painted it, there was a huge earthquake in Fiji which threatened to bring a large tidal wave to its shores. Bill Johnson, our senior pastor, looked at the painting and with the prayers of the people in the meetings began to pray that it would be stopped. Later, when the wave hit, it was small and didn't bring damage to the island. God can use prophetic art to bring about intercession for what can happen around the world! Here are some exercises you can do as you activate your intercession through the arts.

EXERCISE IN PROPHETIC INTERCESSION:

Take time and ask the Lord for a person who needs to be touched today. It could be for physical or emotional healing, encouragement, or comfort. Ask the Holy Spirit what picture would release healing and then begin to draw or write what He shows you. Give it to the person after you are done and ask what it means to them; then connect with them again after some time (a week or more) has passed, and see how things in their life or situation have improved. Many times God gives them a different perspective through the art that releases the grace needed to see their life laced with hope in every area, releasing breakthrough, and other times we have seen incredible miracles of transformation.

You can also release prophetic intercession for a country or for a specific concern. Many people have written songs, or done art pieces for a country, missions trip, or other concern.

Ask the Holy Spirit to bring to mind a person, country, or concern that you have and ask him if you are supposed to release a dance, song, writing, or art piece for this.

Now, take some time, turn on some music and begin to create what God shows you on the following page!

PROPHETIC ART:

GROUP EXERCISE:

You can either have the leader share about a specific issue or person you want them to intercede for or you can have the group decide individually on a person or cause. Then, meditate as a group by turning on instrumental music and let God fill you up in His Presence, showing you what to draw or write. Make sure that you are filled with hope and pray from heaven to earth, releasing God's love into that situation or person. Ask God for pictures that will transform that situation and share as a group what you saw in the Spirit. Take time to pray into what God revealed to you at this time. After the group shares, you can choose to do a group picture or draw individual paintings during this time. Let the canvas be saturated by the colors of miracles as you create and it is released through this process. If you can, give it out to that person, sharing with them what you saw as you made the art piece and see how they respond. I would encourage you to leave about one hour for the group to draw or write what they see. They can either paint together with acrylic and canvas or they can do a large piece altogether. This is up to you and what you feel the Lord is doing.

TESTIMONIES:

CHILDREN'S EXERCISE:

Children love to partner with heaven and release pictures or words for people who are in need, as well as pray over countries and places where God wants to move. I asked our Bethel Junior High students to draw pictures and write letters to orphans of the Rwandan Genocide, whom we visited in December, 2009. When we saw and read these letters as a team, we began to cry! These children became our partners in art intercession to see the spirit of death broken off of the youth of Rwanda. When we went to Rwanda, each child received one of the drawings created by the junior high students with their name on it. As these youth have experienced their identity as a son or daughter of God, they now can give it to children all the way around the world through art which crosses every language and cultural barrier. God is good *all the time!*

So if there's a nation, a people group, or a particular prayer need, have the children or youth begin to partner with heaven in what the Holy Spirit wants to release to bring breakthrough and then have them draw and write what they see. Then have them share their drawing or card in a small group, praying those things into existence! If you can, give all those pictures to a person connected to that situation, in order to bless them and then expect to see things change and God's love revealed! Check in with that person after some time has passed and find out what God is doing!

Personal Exercise for Children:

Ask the child to close their eyes and ask Jesus if there is someone they know who needs prayer and encouragement. Explain that it could be a teacher, a classmate, a neighbor, someone in the family, or another country who needs our help. Then, explain how we can actually draw or write something that can bring heaven to earth and change that situation. Give them some art materials, have them wait on God for 2-3 minutes and then have them begin to create on this page. If you feel this needs to be given away after they are finished, have them draw another one on a separate page and give it away. This way you will have a copy for others to see about how God used their art to transform others.

CHAPTER 5
Prophetic Arts in Worship

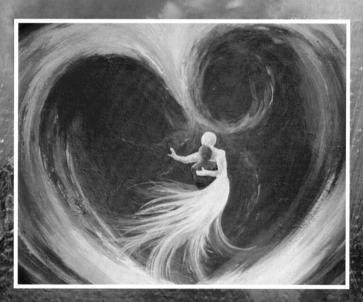

Intimacy *Artist:* Katie Nelson

*God desires us to worship Him with everything we have
and everything we are! As we see and hear about who He is through music,
art, and dance we begin to see the heart of Creator God moving
and speaking in rich fluid tones of colors, sounds, and movement.*

One of my greatest joys as a believer is the synergy that is released when we come together to worship and create in God's presence. There is such a rhythm of heaven as dancers, musicians, singers, and artists partner with heaven to bring God praise and glory. It is here that we can get lost in His presence, creating in adoration and worship for Him! This brings God glory and releases our hearts, bodies, spirits, and minds to creatively worship! We have to understand how *significant* this is both to the corporate body and to the individual person who feels the presence of God through the different art forms. It reminds me of a great orchestra, where the Creator is conducting a great symphony of movement, colors, sounds, and words to all shape the prophetic image of true communion, celebration, joy, and praise! I believe that all of heaven longs to reveal its secrets to people who will worship Him in Spirit and in Truth.

Many of you may wonder about how all of the arts began to come alive here at Bethel in our worship services. Both Bill and Beni Johnson, senior pastors at Bethel, have a heart for worship and the arts. The arts that we do on stage during worship began when a woman named Renee Cooper (now head of our worship intercession teams at Bethel) first shared with Beni Johnson about her dream for the arts to become a "voice" of intercession in times of worship. This art became an instrument for the desires of God to be released through a time of worship. The artists would ask God what He wanted to release over people and into specific circumstances, and as they created these pictures from *His* perspective, the atmosphere would change!

The following section was written from a personal interview with Renee Cooper about her journey in seeing that dream become reality:

> It is interesting how the arts in intercession got started here at Bethel Church. Renee Cooper, who has always had a love for worship and for the Arts wanted to see how colors and movement could become expressions of intercession during worship. Renee's desire to see the arts reestablished in the church was birthed out of her love for intercession and worship, and in 1998, she began her spiritual journey into using the arts as intercession. She was hungry not only to look into the spiritual realm, but to combine color and movement with the sound of worship in such a way that would be the very intercession calling the artists back to the church! As she herself began creating in the presence of God, that very act was prophesying that the hearts of other artists would be awakened to do the same. Currently, her passion has been to teach artists and intercessors how to move with the Holy Spirit, and release their intercession through the arts. As one who is very sensitive and aware of the movement of the Spirit, her desire is to help those who have the same giftings to find freedom and a different avenue to release their intercession.

> She and her husband, Marc Cooper, who is an accomplished musician and who also has been trained in the arts, have partnered together to see how the Creator of the Universe can create as different art expressions can be partnered together in times of worship! When Bill Johnson started to pastor here at Bethel Church, Renee asked his wife Beni if she could begin to do intercession through the arts by forming teams of artists who would paint on stage during corporate worship times, and create pictures that would represent what God was releasing over the people. Beni

agreed and this new ministry began to take shape. Renee commented, "At first, the artists were afraid of painting in front of a lot of people. That is when the Lord told me if I let them paint behind the curtain, what I was birthing would be birthed in fear, so I never let it happen. It was important to break off fear and the other reason was to break a poverty spirit off of the artists. We began to offer their paintings for sale in order to break off the spirit of poverty." This was to help instill in them their worth as artists, that they truly could create things that would bless people, and those things were worth being paid for!

There is such a rhythm of heaven as dancers, musicians, singers, and artists are partnering with heaven to bring God praise and glory. It is here that we can get lost in His Presence, creating in adoration and worship for Him!

Renee also said, "One of the greatest blessings from the arts is that colors, movements, and music in worship can all interplay and prophesy life. As other artists and intercessors have joined in, there is a creativity that is being released and you can corporately feel the heart of God moving through the shapes, colors, and sounds. People are always approaching the artists who paint, discussing how their paintings have impacted them!" Here is a testimony that highlights one of those times. One evening at church, Renee was painting a shield. It represented a prophetic word she had received about new armor being given to the church. A man approached her about the painting, and shared that his family line had 4 generations of pastors. He felt the painting was for him as he had cancer and the shield represented God's protection. He also felt this picture was a sign that he was healed! It is amazing how God can use a painting to speak a word directly to someone! In another time of worship intercession, she created a painting with a spinal cord lit up in yellow. A woman came forward who had severe trauma to her back and also had bowel problems. She felt like God had healed her through the painting and bought it as a memorial of His goodness!

God desires us to worship Him with everything we have and everything we are! As we see and hear about who He is through music, art, and dance, we begin to experience the heart of Creator God communicating in rich fluid tones of colors, sounds, and movement. In closing, Renee feels like the arts are truly going to go to the next level! We will be creating things we've never seen before! I heartily agree with her! We will have the ability to access and create from the unseen realm with greater ease. The art will become what Renee calls "living interactive art" and she feels what we experience in our dreams (in the night) will begin to be released more through the arts. I have gleaned so much from Renee in pioneering intercession in worship through the arts.

As I head up the arts in worship during our school of ministry sessions, many students end up painting what the speakers talk about or give a prophetic word for the whole student body. One of the great things that happens as we create prophetically in worship is that God's Words

come in image form on the canvas! As my husband, Kevin Dedmon, and I have taken out teams to other churches, students paint what God is speaking during the worship time and then share their prophetic interpretation after they paint. They then ask people from the congregation to paint with them on stage as well. Churches end up either keeping the paintings and hanging them on the wall, because of their prophetic meaning or people in the congregation take them home. But the most interesting thing about these paintings is that most of the people who paint have never painted before. That's right! God uses their risk and their passion on the canvas as they worship! This is true prophetic art done in worship to God. This also activates people who have always loved to paint, but have never seen their gift as an act of worship! Our teams that travel to other churches to impart the culture of the Kingdom take prophetic art with them to do during worship, and probably around 90% of those places continue using the arts in worship after we leave! This is lasting fruit. As I have introduced this to other churches, the feedback is unbelievable! God is speaking not just through sounds in worship, but through colors and images, conveying His heart, transforming congregations and people's lives! So many people call or email about the impact this has as the artists paint and share that it is becoming a movement! The arts are bringing glory back to the Creator of the universe and to His people! This is such an incredible time for the church to jump on board! At Bethel, we have learned that we need to prepare before we paint, just like the worship teams. There is certain protocol for preparing beforehand, intercession, dress, and selling of our art which may be helpful for you as you raise up teams or paint yourself (see index page on Arts on Stage Protocol). By the way, I have also released people to write prophetically during worship and had them share their interpretation as the painters do after the worship time. This can be amazing. I have also had people write about art pieces that are being created during worship and had them share about them after the worship set when the painter brings up the painting. In church services, if there is freedom and if the pastor has given you permission, it is such a blessing to have the artists share about what they created, releasing a prophetic word to the church of encouragement.

INDIVIDUAL EXERCISE:

Set up a canvas with paints and grab a pencil or writing device. Begin to turn on some worship music and ask the Holy Spirit to come! He will begin to show you images, pictures, colors, and movement. Now begin to create whatever you see. Ask the Holy Spirit to give you a picture about what He wants to release through you as you draw and sketch it out here.

SKETCH:

After you have it down, begin to sketch it now on your canvas with the worship music playing in the background. After you are done, begin to use paint. Begin to just let go and paint with the Holy Spirit. There may be times when you sense His Presence so strongly that you don't know if you are painting in heaven or on earth! You may just see movements of color and not necessarily a distinct picture or image. Feel free to turn your canvas different ways at different stages of your painting as the Holy Spirit leads or you may be led to leave the canvas on the easel as it is. More than anything, stay connected to His presence and delight in Him! Make sure that you do this exercise for at least 30-60 minutes. Look back at the painting once you are done, and ask the Lord for an interpretation of the piece. You may even ask other people what they see in your painting as well!

TESTIMONY:

Write down what happened as you painted or created during worship:

If you desire to do this at your church, talk to your pastoral leadership to find out if this is something they want to pursue. If so, begin to pray for a team to join you who could meet with you on a regular basis so that you can form a vision and become unified in what you want to see happen within the Arts on Stage during the worship service.

As you paint during a worship service at church, make sure that you prepare ahead of time and set up your supplies completely so you have time to pray with the rest of the team. Make sure that you tune in to what the Holy Spirit wants to say through your art and movements. It is important to honor the worship band by not crowding them or obstructing their view of the people or overhead screens. You are working together as a team. You may put out a basket with a sign that explains that you are selling your artwork with a half page form for people to fill out where they can leave their name, phone number, and description of the painting if they want to purchase it. Run this by pastoral staff to make sure that they agree with this. After you are done, clean out your brushes and debrief in prayer with your team. After the service, make sure the whole team stays to clean up so that the bathroom and the area look better than when you started. This is another important display of honor. I always debrief with the team on what God was speaking and see if there are common themes or colors God was releasing through the team as well.

GROUP EXERCISE:

Many times, we have people work on the same canvas together. As an exercise, get together with others and turn on worship music. Divide up your group to draw and paint together on a canvas. You can choose to have two people partner on one canvas altogether (Partnership is *powerful!*) or use individual canvases. Paint and create for an hour. Share about what you saw in the paintings and write it down. You can give out the pieces you did, or use them as personal intercession pieces for what God is doing in your own lives.

Write down what happened as the group painted and what you learned:

Children's Exercise:

Gather children and talk about how we worship God, sharing on the different ways that God speaks to us through music, dancing, and now through art. Prepare the canvas and the paints, making sure that you have a smock/apron or old clothes that can be permanently marked with paint. Now, pray with them and ask the Holy Spirit to show them a picture about what God is saying at that time. Then have them paint it. After the session is done (30 min.), have them each share what they felt about each painting. You can also have them comment on each other's paintings as well if you have the time. Make sure that you encourage them in their painting and share what you saw in it as well! Affirmation of *who they are* and *what God loves* about their creation is key! I also want to add that I have had children paint during the church's worship time and it has brought so much child-like faith. As the children share about their painting and the interpretation, you will see how powerfully God uses children to speak the very heart of God to the congregation.

Testimony:

CHAPTER 6
Teaching Prophetic Arts to Children

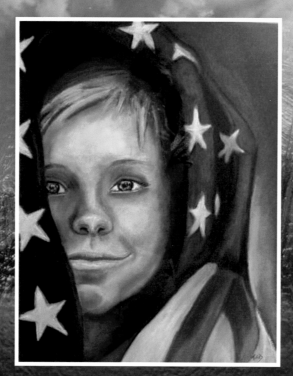

Freedom *Artist:* Theresa Dedmon

It is amazing to see how accurately children can hear from God with a colored

pencil in their hands. One of the greatest rewards as you release children in the

arts is that you are raising up a generation who not only knows about the truth,

but can create images that show God's prophetic message in a tangible form.

As I began to work with children and release the supernatural power of the arts, I saw how easy it is for them to paint from heaven's perspective. This journey started when I was on a mission trip to Tijuana in 2003 and I was asked to head up the children's ministry during multiple church services every night. I began to train nearly 20 different children's workers about how to teach children to hear from God by listening to soaking instrumental music and asking God for pictures about what He loved about them.

Whenever I teach children about the arts, I speak about the core value that God is always good and that He has a destiny for them. We go through Psalm 139, when I share about how He formed and knew us in our mother's womb. At this point, I have them close their eyes and picture all the love that they could ever imagine in one person, even more than what they have seen on TV or anywhere else. I explain that Jesus is that person and that He took all their pain and all the bad things they have done when He died on the cross. I tell them that Jesus wants to know them *now* so that they can "feel" His love, not simply know about it from a distance! 1 John 4:16 states that "God is love." In this place, they begin to tap into the power of God's love through an *experience* in which they can see unconditional love in Jesus' face, touch, and words in their imagination. God wants to sanctify every part of us – especially our imagination.

> *God wants to sanctify every part of us- especially our imagination. One of the most powerful tools that we have is to understand who He is and what we carry.*

One of the most powerful tools of transformation that we have is to understand *who He is* and what we carry. After the children see Jesus, I tell them to ask Jesus to show them what He thinks about them. Many times Jesus takes them to places that are particularly significant to them as well. After I let them soak or wait in God's presence as they go on an encounter with Jesus, I ask them to *draw* what God showed them. As I sent out my teams and they taught about these kinds of encounters, they returned with pictures that rocked everyone who saw them! Children ages 3 to 15 were drawing incredible pictures of angels, as well as Jesus loving them and their family. I realized that *paintings* open up a way for children who can't articulate well or verbalize their feelings or experiences to express their hearts and can reflect to us what God is doing on the inside.

We also take children with us when we go on "treasure hunts," a model of outreach used at Bethel in which we ask the Holy Spirit for "clues" (words of knowledge about people, places, or prayer needs) to help us find His "treasure" (people who need a loving touch from God!). During a prophetic arts conference at a church in Kirkland, Washington, we were teaching the people how to do prophetic art treasure hunts (We ask God for "clues" to lead us where we should go and what people to look for, and then before we go into the city, we create drawings and other prophetic artwork to give to those people and declare God's love over their lives! See index for "Prophetic Arts Treasure Hunt" form).

Here is a testimony of what happened when a 5-year-old girl from that church drew a picture inspired by the Holy Spirit:

As we were preparing to leave the church to release God's love into three different hospitals in the city, a woman approached me and said her daughter Lilly had drawn a picture for us to take on our treasure hunt! She was SO eager to give it to us. She had drawn a simple but distinct picture of a woman with short brown hair with highlights, wearing a blue dress with red pattern. When I asked Lilly about what the picture meant she told me confidently, "Well, God showed me this picture of a lady in a wheelchair so I drew her dancing and praising God." I pointed to a squiggle she had drawn in pencil above the woman and she said, "The glory of God is over her head." Now *that* is the power of how children can see and *believe*! Lilly ended up coming with us to the hospital and brought her picture with her. We had such great expectation for what God was going to do. Sure enough, as our car pulled up to the entrance of the emergency room, the *exact woman* Lilly had drawn was sitting right out front in a wheelchair! She had short brown hair with highlights, and was wearing a blue hospital gown with a red pattern on it! We *knew* God was up to something! So we jumped out of the car and Lilly came with us to show her picture to the woman. Lilly was a bit timid at first but we explained to the woman that Lilly had drawn this picture about an hour before our arrival and that God had told her He wanted to bring her healing and life. The woman was *floored*! She explained to us that she had just been released from her *fourth* back surgery, and that though she was overjoyed to be returning to her family that day, she was still in alot of pain. She allowed us to pray for her, and saw a *major* improvement in her discomfort. She was able to stand up and return to the sitting position without the pain she was experiencing before we had prayed! She was SO filled with joy, and blown away by how God had revealed Himself to a 5-year-old stranger in order to show His love! (Written by Melissa Cordell)

My team and I have also taught children to prophesy and paint during worship. As they draw pictures, they are asking God for a prophetic message during the worship serivce. After worship, the children explain the significance of their paintings. The pictures release words for people in the congregation that are so full of God's heart that it astounds the congregation and pastoral staff. If you teach a child to paint, they will paint from heaven's perspective and change nations! Anne Kalvestrand, one of the leaders in our Missions Department, has been teaching children at Bethel for years on the principles of intercession. They have done pictures for world leaders, prophesied over nations through the arts, and declared truths as they paint. One evening, they led the children in dancing before the Lord in worship and intercession. They only did this for about 20 minutes but what the children shared from the experience was amazing! The leaders explained to the children about the biblical context of David dancing before the Lord with all of his might. This was the third time they had practiced this with the kids, and they learned that when you introduce something new to children, it can be a bit awkward for them at first, but as they have freedom to try it over and over, their boldness and faith increases. That night the children exploded in dance! One of the adult male leaders led the young boys in dance, and it was very helpful to have him there to create a level of safety and example for them. At the end of the dance, one of the leaders asked the other kids what they felt and saw when they danced, and what God told them. There was an obvious theme of God as a protector in the children's statements, though they had all felt that independently at the time. Here is a record of what the children expressed:

Rachel: "God said He was going to bless us. The angels were guarding the door so that Satan couldn't come in."

Noah: "God told me that He loves me. The angels said that my favorite color was purple."

Eleana: "God said He was watching over us."

Nick: Said "I saw angels transformed into a force field around me. They were all around me."

We also invite children to receive prophetic words of encouragement for church leaders, and then draw pictures of what God shows them. These pictures shape and change people's destiny! It is amazing to see how accurately children can hear from God with a colored pencil in their hands. One of the greatest rewards as you release children in the arts is that you are raising up a generation who not only knows about the truth, but can create images that show God's prophetic message in a tangible form. We are now teaching prophetic art classes to our children at Bethel and the impact is staggering! If you want to see children carry revival to your neighbors, just have them paint or draw a picture for them.

The following is a testimony from Claudia Kornaros who came to a Prophetic Arts Conference, which I led. After she left the conference, she went back to her house, and released her children in prophetic art. Here is what happened!

About three weeks ago I invited the kids to start our day soaking in God's presence. I gave them the option to lie quietly (under blankets to make it fun!) and/or sit at their tables and draw or color a prophetic picture while listening to the kids' soaking CD (which I bought at Bethel). My 10 year old boy (Michael) said he wanted to just color a picture and *not* do a prophetic picture. I didn't push it. He ended up drawing a really cool picture of a downhill skier. He then told me that as soon as he sat down to color, the Lord told him to draw a prophetic picture of a downhill skier. He said to me afterwards, "Mama, as I was drawing the skier the Lord was talking to me and said, 'Michael, your life is going to be like a downhill skier. You will fall a lot but when you do, I want you to keep getting up and keep racing down that hill.' My son's countenance was so full of joy and peace! I was amazed. He had heard from his Papa God.

A woman from our church has been very ill for years. Her husband called and asked if any of the pastors' wives could come and pray with her because she had been feeling especially down due to her lengthy illnesses. I asked my children to seek the Lord for any messages and/or pictures that He might want them to draw for this sick lady. The kids did not know who she was but I told them that I would be going to her house the next day to pray with her and I would be bringing her their pictures. That was all that I told them to do. Each of them got busy and began to seek the Lord. They all drew pictures for her and dictated a letter to me to attach to their pictures. This is what they wrote with their pictures:

"This picture is for you! The hearts are your heart and the design in the middle of this beautiful picture is God. God wants you to know that you will be healed of all your sicknesses. You are so special! When God looks at you He thinks that you are beautiful!" (Elizabeth, Age 7). "This angel represents God and when you come into your room you will be healed and the angel will say 'Praise God'. When the angel says 'Praise God' all the colors of the rainbow come around your door. The colors all around your door and steps made you feel better from your sickness. The writing on the door says God is Luv. The Flower is God." (Isaac, Age 5) "This is a prophetic picture for you to heal you of your hurt. The lines of the rainbow symbolize God pushing healing through the streams of the rainbow that are coming into your bedroom. The words on the door are put there by God to declare your healing. The light in the doorway is God's way of telling you that He will never break His promises that He has made to you. The first two letters are outlined in red with Jesus' blood to tell you that it is really by God's power that you will be healed." (Michael, Age 10).

I arrived at her house and presented the letters and prophetic pictures to this very delicate and fragile woman. She just sat in her chair and as she looked at the pictures and read each letter she cried and cried and cried. She was so ministered to. I stood their rejoicing in my own heart for what I had learned at the prophetic arts conference about prophetic pictures. I was witnessing the Holy Spirit speaking to this woman through the tender and thoughtful messages that He spoke to my children's hearts for her. I was able to enter into a beautiful time of prayer and comfort with her after that. I left her with those pictures in her hand. Her heart had been lifted as she knew that her heavenly Father had not forgotten about her. He had reminded her of His love for her through the artwork and notes of 3 little children. (Testimony from Claudia K., San Francisco, CA)

Let's begin to look at the power that a child has to not only verbalize the Kingdom but to draw and paint what the Kingdom looks like! They might be the vehicle that God will use to bring healing to a family member, friend, or neighbor. Here are some exercises you can do with your children to begin to activate them in creative partnership with God!

Children are so full of faith and do not question that God can speak to them through their art, so this is a great way for them to process what God is saying and how they can bless others. Also, many children cannot articulate what God is saying, but they can draw it. This opens up other ways that they can communicate the Gospel and what God is saying.

WORSHIP EXERCISE:

As we said in the previous chapters on intercession and worship, you can activate children to begin to create paintings for these purposes. You can either have them paint during worship in their Sunday school class, in a church service, or in your own home! Take some time and pray with your child(ren), asking the Holy Spirit to give them a picture about what He is saying to the church, children's church, or to your family. Have them soak in God's presence as they have their eyes closed and get a download from God. Then with an easel (at their height), a tarp, and clothes that can get permanent paint on them, begin to let them paint whatever they see. Make sure that you give them at least a half an hour to do this. After they are done, ask them to share with the people who were watching what they painted. Watch for the reaction on the audience's face!! It will blow you away! Afterward, I always debrief with the child or children about what they painted and what I saw as well to encourage them. If you don't have easels, you can improvise with a kitchen table.

Activation

As you begin to train your child to do prophetic art during worship, buy them a sketch pad with colored pencils and oil pastels. Have them begin to draw during worship time at church or when worship music is on at home. Look at their pictures and comment on what you see prophetically in their pictures. This way you will be teaching them to continue to activate and do this on a consistent basis. This way their anointing and their prophetic heart as an arts worshipper will grow and you can encourage them in what they create.

Other idea

If you can't use paint, you can also have children draw with colored pencils on a sketch pad so that they get used to the idea of creating during worship and see what they create! You can also use butcher paper and markers on a table for smaller children as well. If you want something more permanent, you can use a painter's canvas tarp with permanent markers and have them begin to create on that as well with writings and drawings. It is so much fun for you and for them!

EXPRESSIVE PORTRAIT EXERCISE:

You can do this exercise either with colored pencils, markers, crayons, or oil pastels. Have them draw a picture for someone who needs encouragement. It can be someone who is sick and needs healing, has a birthday, or needs a touch from God. Pray with them before you start so that they can hear from God for that person and then let them begin to draw what they see. If you are a teacher in a children's class, you can partner people up for this exercise. You may need to help them give it to the person they made it for if they are young or timid. I also ask them to write the interpretation of what they drew and make sure they sign their name. Again, you can have them take this to school or to meetings so that they can continue to do this on a consistent basis. The more that they do it and get positive feedback, the more they can grow in this area.

Intercession Exercise:

If you want to intercede for a country or for a particular cause or reason, this is a great way for children to pray without getting bored or running out of words! This exercise makes them feel powerful as they get pictures from God and then they can create them. Ask the Holy Spirit to give them a picture and pray with them. Many times I will turn on soaking, meditative, or worship music. Give at least 20 minutes to an hour for this exercise, depending on their attention span. Then, write on the interpretation on back of the art piece. It's awesome to pray into these pictures as well because you are giving value to what the kids have created and partnering your hearts in faith that those things really will happen! You can also have the children put these pictures on the walls of their bedroom so that they can continue to intercede, on your fridge, or other places so that you and they can be reminded to pray for that person or situation as well.

Testimonies:

CHAPTER 7
Teaching Prophetic Arts to Young Adults

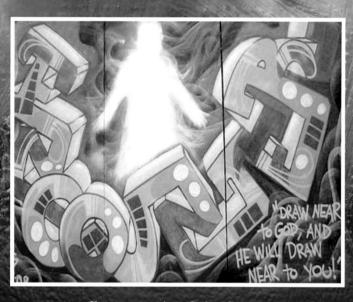

Encounter *Artist:* Joshua Greeson

I believe that the Arts carry tools of transformation
for youth both inside and outside of the church.

Many of us wonder how we can reach out and touch the youth of our nation. I believe that the arts carry tools of transformation for the youth both inside and outside of the Church. I have seen God radically touch the youth through the arts! One time in particular was when I was teaching a prophetic arts workshop at a Jesus Culture event in Atlanta, Georgia. At the time, I was teaching youth how to prophesy by drawing an art piece for another person. I was teaching a group who had never done it or heard of prophetic art before. I paired them up, making sure that they didn't know the other person they were with. As they paired up, they placed a hand on the other person and asked God to show them something about that person that was precious to them personally. One youth drew a picture of a certain iPod, music notes, drums in an outdoor setting, and a school on his paper. As he gave it to this person whom he had never met, she almost fell out of her chair! She pulled her iPod out of her purse, and placed it on the paper. Yes, it was a perfect fit! He found out that her iPod just happened to be her favorite possession! She then told us that she had just graduated with her music degree and that she was in a drum team where they played in outside clubs and events. The young man couldn't believe that God could use him in this way! This picture really confirmed to the young woman how much God loved her and what a large role music would play in her life.

It is amazing when you have young adults paint during worship services as well. During their sessions of radical worship, Jesus Culture invites young adults to paint, bringing the presence of God down in a tangible visible way that they can see! It is done by them and reflects the way they see God. One time I was ministering in Willetts, California, at a church where some skater youth came in all dressed in black. You could tell that they were uncomfortable and didn't feel like they fit in. So I gave them some paper and pens. They began to draw skater symbols and graffiti about God during worship. After they were done, I shared with the congregation and they applauded the work, which we hung up in the church! In this way, we valued what they had created. As I hung up their work, they also felt that the church had accepted the way that they uniquely expressed their worship to God. This is how you reach other cultures and give them a place in your church or community and church life!

Taking your youth out on outreach is another way that you can activate the young adults within your community and church. When I lived in Huntington Beach and did outreach events in the community, I always took the youth with me, because they have such passion and anointing. I have done body tattoo art in the skateboard parks with permanent markers. I have done destiny drawings for youth, as well as had them create drawings for others. It is so much fun to activate youth and see that they can touch others! Many don't feel comfortable talking to others in the marketplace, but if you give them something to create, draw, tattoo, or create, all their fears melt away!

If you give them a place to share about what they painted, it will speak to the rest of the people who are there as well as to the value you have on them to share their heart.

In November 2009, I ministered at a church in Ventura, California. As we were preparing for outreach, I looked down and saw four youth who were hungry to go out into the community and reach people through the arts. My heart was particularly drawn to one fourteen-year-old named Maria. I had the youth come with me into the city. Some were blowing up balloons, making swords to knight young boys or crowning young girls as princesses.

Others were drawing prophetically with chalk on the boardwalk. Maria decided to draw pictures for people and do a prophetic tattoo for someone. She got so fired up! When she came to our healing service that night, one of our team shared about how God had healed her of fibro myalgia. As she heard this testimony, Maria's heart leapt within her. She was diagnosed with fibro myalgia two years prior and was also on anti-depressant medication. As she got prayer, she was healed! In the morning all of the outbreaks and growths were disappearing and she actually slept through the night! Maria had found value through creating art, which brought her to the service, where she was healed! We need to restore value and purpose to our youth by letting them express their God-given creativity, which can transform others around them!

YOUNG ADULTS EXERCISE:

Have the youth paint during a youth worship service with the medium and with the type of art that they love. Have them pray about what to draw, making sure that you explain to them that the prophetic has to be encouraging, positive, comforting, and edifying. Then let them go! Ask them for the interpretation of what they created and get ready to be rocked by their answers! Also, if you give them a place to share about what they painted in the service, it will speak to the rest of the people who are there as well as to the value you have on them to share their heart.

TESTIMONIES:

Write down what happened as you released the youth to paint during a youth or church service:

EXPRESSIVE PORTRAIT EXERCISE:

Have the youth pair up and then draw something that that person loves or something about what God loves about that person. Give them around 15 minutes to create it. Colored pencils, markers, and oil pastels are successful for this and can be carried out to public places where you can do this as well if you want to reach out to the community. After they are done, have them exchange the art pieces and share the interpretation of each one, asking for feedback on what this means to that person.

Make sure they put their name on it as well. If I am in a group setting, after everyone has shared, I ask those that were really touched to share from the front so the whole group gets the benefit of what was created. The testimony propels them to see what is possible if they continue to practice.

TESTIMONIES:

Write down how others were touched by their artwork:

SPECIAL OCCASION EXERCISE:

You can have the youth draw something to give prophetically to someone around them. This can be for a birthday, if a person needs healing, or just because they need some encouragement. They can use any type of medium which makes it fun. You can do collage, photographs, and use other mediums to prophesy or intercede for someone.

CHAPTER 8
Healing Through the Prophetic Arts

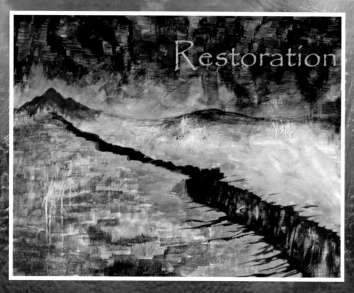

Restoration *Artist:* Francesco Sideli

Painting releases healing inside of us and it can also

do the same for those who don't know His love!

Personal Inner Healing

As we have released prophetic arts around the world, we have seen so many people healed in their own hearts. As I mentioned in chapter 2, many people don't feel good about what they paint because they are living with a performance-based mentality, where standards are not set by God, but by a certain expectation of what is valuable within the culture. We must personally understand and train others in the understanding that God has made each person with the inherent ability to create through His presence, and that each one of us reveals a unique aspect of His heart. As we create from this, His original intention, it brings value and honor to the One who created us in the first place! If I criticize a work of art, it does not give honor to the one who created it. If we criticize who we are and the work of God that flows through us, we are actually saying that God made a mistake when He created us. When a person can be free to enjoy God's presence as they create, then no matter what God shows them, they are in agreement with all of heaven. If we can't accept the way God made us to paint, draw, sing, or create, then we have no value for the diversity of His creation. God doesn't want His people to all look the same or create or think the same. *He loves us just the way we are!* I cannot tell you the countless number of people who have been healed of a religious, performance mentality as God and others have blessed *whatever* they create! This also breaks off all of the negative words that have been spoken over them about what they have made in the past. If you have not accepted how God made you originally and rejoices over what you alone can create, it is time to get free now. From now on, every time you create something, bless it and thank God for who you are! Begin to see yourself as He sees you! We are created in Christ Jesus to do *good works*, which He prepared in advance for us to do! And God who began a *good work* in us, will carry it to completion (Philippians 1:6). This does not mean that our God-given ability is not valuable but if we *don't* see that what we create is innately good, we won't enjoy the process.

> *We must understand and train others that God has created each person with the inherent ability to create through God's presence a certain aspect of His heart, which brings value and honor to the One who created them in the first place!*

There are also countless artists who have never fully enjoyed their gifts of creativity because they have learned to be so critical about their work either from their teachers in the past or from themselves. I remember when I first came to Bethel and I learned to create out of God's presence and love for me. For the first time, I created a picture that didn't have to be perfect for it to be valuable. I simply enjoyed the process of creating something with childlike faith, rather than out of anxiety that I had to make everything perfect. I had found so much joy that had been lost in something I loved so much- *creativity*! Shortly after this, I was leading a mission trip to Mexico and painted a picture of a woman begging on the streets for bread. My mother, who is an incredible artist, was coming to visit and I told my husband that when she saw the painting, her first words out of her mouth would be to criticize my work. She is a wonderful teacher, but because of her criticism when I was young, I had never known the power of creating without first evaluating the flaws in my work. When she came and looked at the painting, she examined it, and began to share with me about what I could have done better. Immediately, I told her that I liked it just the way it was. You have no idea how freeing this was for me since I had been bound by what others thought of my work for so long. I

was healed so that I could paint in God's presence free from control or performance. Of course, this doesn't mean that I don't ask people for constructive feedback on how I can improve, but I never judge or devalue the process of simply creating with Jesus! I no longer start in fear, but co-labor with Christ under the influence of His anointing. Afterwards, I can also enjoy the process of critiquing and refining my skills and abilities. Prophetic painting can bring such deep healing to us personally as we create. I have known many people who have experienced both physical as well as emotional healing as they painted. Here is one of those stories:

> Through painting God has brought me some deep healing. Recently I was painting (actually the Lord told me to paint my healing so that's what I'm doing--piece by piece). This one evening I was painting another segment of the picture which I really was enjoying--the colors were vibrant blues, it looked great and I was having fun. But as I continued painting, I started to feel really angry and then began crying. I began painting tears on the canvas. I couldn't stop weeping. I knew something was happening but didn't understand it. Three days later, the Lord showed me that although what I had painted looked beautiful, I was rotting underneath with unforgiveness. He showed me my heart was full of unforgiveness (issues I thought I had dealt with). Then He told me to use a felt pen and draw big tear drops all over the part I had painted. Inside each tear drop He told me what to write--the different areas of unforgiveness I was feeling . When I was finished, He told me to re-read each item of unforgiveness and say out loud, "I choose to forgive _____ for _____." After I did this, I would paint over each tear drop with red paint (since it was now under the covering of His blood). And so I moved on to the next item of unforgiveness until I had finished and the whole area was painted red. It was a very emotional but freeing time. The next day the Lord told me to paint with white over the whole area that I had painted red - it was a fresh start to life. After the area was painted in white, the Lord showed me to outline the white in red(about 1/2 inch wide), and on the inside of the white to paint pink. I'm not sure what He wants me to paint on the new white area, but He wants me to remember the red (the blood of Jesus), the white (the purity of a fresh start once I confessed my sin), and the pink symbolic of the healing He was bringing me through this. This process took about 5 days. (Barbara Pruden, BSSM 2010 student)

I can't tell you the number of people who have been transformed as they have gone through inner-healing. There is a man in our church named, Bill Grubbs who draws prophetic healing pictures for individuals as they experience inner-healing through our Sozo (inner-healing) ministry at Bethel. They then have a picture about all of the things that God has done, just like what Barbara experienced. Here is a testimony about someone who was physically healed while painting. I was leading an Arts Conference with some churches in the bay area. I was teaching about how to draw in God's presence during a worship segment. One person drew a picture which had leaves for healing of the nations in it. As she shared about how this painting had released her to feel God's love as she painted, I asked if she had any pain in her body. Many times the paintings are links to what God is saying personally to the one painting. She said that she had felt pain in her knees for years with no relief. I told her that unbeknownst to her, she had painted a picture for herself! Immediately the light went on and all the pain left her body and she was healed!

Painting releases healing physically and emotionally, and the good news is that it can also do the same for those who don't know His love!

Physical Healing

We are also seeing many healings in the marketplace through prophetic art. People go out into their community, draw a picture for someone and then give it to a person in need of healing. As that person just holds onto it, they are instantly healed! In other words, people are healed *before* anyone prays for them, just by holding the painting. In Acts 19:11 and 12, it says that "God did extraordinary miracles through Paul, so that even handkerchiefs and aprons that had touched him were taken to the sick, and their illnesses were cured." Here is an example of someone who was healed just through touch like in Acts. In November 2009, I led a team to Ventura, California, to minister to two churches. After an evening service, the people on my team drew "word of knowledge" pictures for those who needed healing (A word of knowledge is a gift of the Holy Spirit through which God reveals to you something about a person that you could never know, whether it's a personal need for healing, breakthrough in a circumstance or something else He wants to touch with His love). One of my team members, Emily Dubasz, drew a picture of water. She felt like there was a person there that night who was hurt from a sports injury that had happened in the water. Two people came forward who had severe back problems from water injuries. As they held the picture she had made, before anyone prayed for them, they were both healed! God is so good!

We also go out on prophetic art treasure hunts (See Appendix), where we ask God to show us people who need healing, and then we draw pictures for them. Here is a testimony that happened when Keith Schaad went out one day:

As we went out into the city, a team member got a word of knowledge about a hurt hand, so as we passed a young couple walking on the river trail, we asked if either had any broken fingers or hand injuries. They said no and as we continued the conversation with them, we found out the girl had uterine cancer. Before we had left the church, we had drawn a prophetic art picture showing abdominal pain. As we began to pray for her, she said she felt God all over her and all the pain left her body! We received another word of knowledge and saw her as a little girl walking with Jesus. She confirmed that she did receive him as a little girl! Then God told us more about the hand injury, and we asked the guy if he was just wanting to "punch a wall." He started tearing up. They had just gotten evicted, she was facing cancer and he couldn't find work. So we prayed for God to show up and asked him if he wanted to receive Jesus into his life. He said yes! So we were able to pray with him to accept Christ! The girl asked if we stopped them because we had heard them yelling just before we walked up. We said no, and they looked surprised! They had just yelled up to heaven moments before we walked up, "God, if You're there, we need you now!" I guess He was listening!

We have also introduced prophetic healing art in our Healing Rooms at Bethel. Here is a recent testimony of a woman who received complete healing from her terminal, cancerous brain tumor through a prophetic art piece!

On October 17th, 2009, David (Healing Rooms Team Leader) called out a word of knowledge in the Encounter Room (our version of a "waiting room") for a problem with the back of the head (which is where the woman had a cancerous tumor). David prayed and the woman said nothing happened. David just encouraged her to keep getting prayer and that God was going to do something. Later on, Thomas (another prayer team member) called out a word of knowledge for tumors, and he also went to pray for her. When he was with her, she told him that when David had prayed for her, she was healed of tunnel vision! Kate, another team leader in the Healing Rooms, spoke to the woman as well, and she told Kate the doctors had said her situation was inoperable and "hopeless". She had only two months to live. So Kate took her to the area of the Encounter Room where they paint prophetic art and worship God. Kate showed her a painting that had just been created of a river on which was written the word, "hope." The woman broke down in tears as she looked at it, and God began to work hope deep down inside of her. This is when God broke off hopelessness and began her journey of healing. This is where I come into the picture. As she entered the main Healing Room with her fiancé, my prayer team partner and I took them aside to pray. She told us the doctors had said her cancer was inoperable. She later told us that her doctor told her if she wanted to celebrate Christmas with her family one last time, she needed to do

I have known many people who have experienced both physical as well as emotional healing as they painted.

it early this year. I declared life and touched her on the back of the head. She said the pain and pressure were suddenly gone! We were praising God when she cried out and grabbed her ear! She then asked us for a napkin because her tumor was literally draining right before our eyes! We got her some tissues, and a whole lot of fluid drained out of her ear. I don't even understand how that can happen! Incidentally, her fiancé had shaking of the hands, arthritis in his wrists, and lower back pain. We asked him how he was doing, and he couldn't find any of those things any more! The next day at church he still had no more problems in those areas, and she said she had stopped taking the morphine as there was no more pain! She had no withdrawals from morphine either! Five days later she e-mailed and said the tumor, that had been the size of a golf ball, had shrunk to the size of a quarter, had no fluid in it, and the doctors said they could find no cancer cells in her body. Praise Jesus!" And it all had started as she gazed on a painting of hope!

Here are a few more testimonies of the power of God to *heal* through prophetic art:

During a Prophetic Arts Conference in Kirkland, Washington, our team of students asked the Lord for words of knowledge about what He wanted to heal, and then began to draw pictures of those body parts, ailments, and what was in *God's* heart for those people. One student in particular, named April Lewis, received a picture in her mind from the Lord of someone who was suffering from degenerative disc disease, so she drew a picture of a spine with missing discs. When April showed the picture to the congregation, an older woman immediately responded and said that she had been suffering in terrible pain from that disease for years! So just like the apostle Paul with his

handkerchiefs, April walked over to the woman and placed her drawing between the woman's back and her chair, telling her to sit with the drawing there and *expect* the presence of God to touch her body! Sure enough, the Holy Spirit began to move powerfully, and soon the woman had *no pain* and full mobility! She was completely healed!

Another time, I was speaking at a prophetic arts conference in San Francisco, where we were also releasing words of knowledge through art. One person on my team, named Micaela Stein, drew a picture of a huge smile that covered her entire piece of paper! Here is her story:

> I asked if anyone had tooth problems after I had drawn the picture. A lady who had just received a root canal raised her hand for the picture. She said when she simply *saw* the picture up front her pain immediately went from a level 10 to a level 6! When she had the picture *in her hands,* we asked her to hold the drawing of the smiling mouth up to her face as if it was her own, and instantly her pain was completely gone! The fun thing is that she had been crying out to God for healing a couple days before and told God if she was healed, she would begin to testify of God's healing to everyone she met.

Micaela also had another incredible testimony during this conference.

> Another favorite encounter was when I drew a picture of seven units/apartments all in a row, with one house broken off from the seven units. The Lord pointed out a man in the congregation to me, and I felt to tell him that he was home, and he was going to feel complete peace and God wanted to confirm that he was in the right place at the right time, that he was where he needed to be. It totally touched this man who had *just* recently sold seven units/apartments and had felt a ton of stress/pressure/chaos, etc. He was just so filled with joy because the word was so specific and he really felt God's love. God's healing touches the body and the soul of those who need His touch!

Music can also be an avenue of healing as well. My husband, Kevin, has often sung over people and they have been healed as well. This is similar to the story in the Bible when David sang over Saul and the demon left him. One time I sang over a person in a restaurant who was shaking violently because of a disease that was ravaging her body. As I was singing, all the shaking left and a complete peace came over her body. We have sung over people, and God's healing is released over their minds, bodies, and spirits. This can be another avenue in the arts, which you can develop for releasing healing.

God is releasing so many of us to think outside the box of what is typical, and to imagine what is truly possible through the power of the arts as we partner with the Holy Spirit. We have seen people healed in so many unconventional ways. One student, Raphael Barbey, was painting during a worship service in Mexico, and a woman in the back of the room who needed physical healing *visibly saw* a lightning bolt shoot out of his painting and hit her, and she was instantly healed! As you read these testimonies and activate in these exercises, you may discover even more ways that God is moving. He wants to reveal how we can take back our inheritance in healing and in creating. Make sure you let us know what happens and e-mail us your testimonies (www.theresadedmonministries.com)

PERSONAL HEALING EXERCISE:

Take some time and just soak in God's presence with music in the background. Then focus on the healing power of God flowing toward you. Now write, paint, draw , or sing whatever He shows you. As you create, let God wash over you. It could happen through the healing of colors that are symbolic for you or it could happen through the shapes and design you create or the words or song that flows from heaven. As you paint or draw, let performance or criticism fall off you and just experience creating with Jesus, letting him touch you. This is especially healing for people who have gone through loss, trauma, or a difficult season. Many times Christians don't take the time to create something for themselves from God, because they think that God only wants them to minister to other people. Scripture says that we are to love others as we have been loved. Take some time and let God love you just because you are you!

Draw the sketch, writing, or song after this exercise here so that you can remember your personal journey (you can do it on another piece of paper and then transfer the finished product here)

PHYSICAL HEALING EXERCISE:

Ask God to give you a picture for someone that you know who needs healing. As you wait in His presence, get a download for what colors, shapes, and writings are key to the piece. Lay your hands on the paper or canvas and ask for a transfer of healing through the painting. Now create it, releasing all of your energy, passion, and love as you create! Give the person the picture with your interpretation of the piece and ask what it means to them.

Write out a description of what you drew, sang, or wrote and how it touched that person here:

PROPHETIC ART TREASURE HUNT:

Review the form at the end of this book entitled "Prophetic Art Treasure Hunt." You can either go out as a group or personally and do this. Fill out the form and draw a picture for someone you feel needs this art piece. Now, go out either as a team or individually and find your treasure, giving away your art piece!

Testimonies and Feedback on What I Learned about Healing:

CHAPTER 9
Prophetic Drama, Writing and Music

Joy *Artist:* Theresa Dedmon

One of the most fulfilling experiences I've had is performing with the awareness of the presence of God. It is like I am partnering with Him to tell a story, and with each word I speak, I can feel him speaking through me.

Once you open up the door for God to speak in the prophetic arts realm supernaturally, you have to open up the door for all of the arts! God likes to speak in so many ways, not just in English or in visual arts. God dances and sings over us! He has the most dramatic stories recorded in the Bible, and they are acted out in our imagination. It is time that we are awakened to what we uniquely carry, not just copy what others have scripted or written. Now is the time for us to create, partnering with the Holy Spirit for specific situations, people, and causes.

I will never forget the time when I was in South Africa and I took a team to minister to the poorest of the poor. We went to a school where they had over 1,100 children who ate only two slices of white bread a day! We had only half an hour to share with all of them about Jesus' love. So I remembered a drama (See Appendix of Prophetic Arts Resources for the script) I had written about children who were given gifts by God the Father, but were enticed by the enemy to leave God's presence just like Adam and Eve were in the Garden. In the climax of the drama narration, Jesus comes and lays down His life so that the children are free from the enemy's clutches after he steals their gifts and imprisons them. After Jesus rises from

> ✦ ✦
>
> *Once you open up the door for God to speak in the Prophetic Arts realm supernaturally, you have to open up the door for ALL of the Arts! God likes to speak in so many ways.*

the dead, He gives them back the gifts that the enemy stole and returns them to the Father's house. After my team performed this drama, all 1,100 children accepted Christ! This is the power of prophetic drama! It can reach people right where they are if we know how to use it under the Holy Spirit's leadership. I also came up with another drama in about half an hour which we took into a prison in La Paz, Mexico. Through this drama, people gave their lives to Christ and were healed both physically and emotionally. The most touching time came when even the warden received Christ!

Here is another testimony about the power of supernatural drama to transform lives. I was leading a women's conference in Truckee, California, when God downloaded drama sketches for healing and transformation.

We've all been growing in our ability to hear the Holy Spirit and to release spontaneous, anointed prophecy that transforms lives. Bethel's BSSM students have been spreading their wings to deliver powerful, spur-of-the-moment prophetic words *corporately*, through performing arts. Theresa was speaking at a women's retreat and had invited three second year BSSM women who served as her supporting team. After Theresa shared her drama sketch, the team sensed many of the women needed to receive a revelation of the importance of being transparent with others. Before the church service, we prayed and brainstormed, asking the Holy Spirit for insight and briefly improvising sketch ideas to add to the drama. Within a *few minutes*, we had prepared a dramatic piece that would prophetically release courage for vulnerability! Loosely rehearsing the idea several times, we headed to the next corporate meeting. As a testimony to the power of God, women wept throughout the room as our sketch drew to a close! Later, many testified how deeply their hearts had been impacted. Prophetically, the piece released an *openness* into the atmosphere that enabled women to actually become more transparent. The tone was set for the remainder of

our ministry sessions and many hearts were restored as *corporate prophetic drama* prepared the way for the Holy Spirit's healing! (Written by Janet Richards)

Our Bethel Christian School also performs incredible prophetic musicals that include dance and drama, and open up people to understand God through the lives of children as they dance and perform theatrically from a Kingdom perspective. We also have a powerful prophetic dance ministry during our nightly church services at Bethel. It is so breathtaking to see God's heart and beauty flow through the dancers as they prophesy His message! As I have gone out to other churches, we have had people give a prophetic word through dance to someone for the church or for a person. Afterwards, people come and are so visibly touched by this act, because it is physically expressed to them in a way that goes beyond words.

We have also prophesied through music over people in the church and this too has such impact, because the sounds from heaven are heard in their unique message for that person!

If we are going to move forward into this "new Renaissance," where all believers operate prophetically in their call, it will come in all art forms and touch people in ways that are *relevant* to the culture through dance, drama, fashion, and music done in excellence. The following section was written by Tiffany Christensen, one of my arts interns in Bethel's School of Supernatural Ministry. As you read, let God fill your heart with fresh vision on the power of prophetic drama:

WHY DRAMA?

Well, if our words can move mountains, and a picture is worth a thousand words, what do you think happens when we join the two together? How many times have you watched a film and been drawn into the story? The power of storytelling has been around as long as humans have been on this earth, and since we are such a visual society, seeing a story played out in front of our eyes has much more impact than merely reading one. Jesus Himself used parables as one of His main teaching tools, and some of the prophets in the Old Testament would "act out" their prophetic words.

Every year at Bethel Church we host what we call a "Holiday Feast" for the poor and homeless in our city. We decorate our church as if it were for kings and lavish the people with an amazing meal to show them Jesus' love. For the past five years, we have also included dance and drama as part of the day to continue revealing God's love. Last year we performed a human video, a drama with no words set to music. The story centered on a girl who struggles with self-esteem and begins looking to things like relationships and drugs to fill the void inside of her. In the end she cries out for help as she lies dying, and Jesus comes, rescues her, makes her clean, and dances away with her. It was so beautiful that several people in the audience began crying and gave their lives to Jesus. The MC explained how Jesus healed the girl in the drama and how he wanted to heal them too, both emotionally and physically. As a result, many people were also healed of physical pain or sickness as the MC prayed.

Another time we put together a drama team and performed a skit called "Father God Gets His Kids Back." (See Appendix of Prophetic Arts Resources) and the response was astounding! Some kids saw that they had the gift of art, others had the gift of making their mom happy, and others had the gift of running fast. Because of watching our drama, these kids realized that they had something special that *no one else had*. It was beautiful.

Presence vs. Performance

The biggest thing to realize when putting together prophetic dramas is that it's not only about performance; it's about the presence of Holy Spirit. You can have something big and elaborate planned out with a set and costumes and special effects, but if the drama doesn't carry the presence of God, then it's just mediocre from an eternal perspective. On the other hand, you can put together a short improv skit in half an hour that causes people to encounter God because *He* was speaking through it! The best way to put together a drama through which Holy Spirit can work is simply to *ask* Him what He wants to do and what He wants to say. There are also anointed scripts with an acting cast that bring ability and anointing together. This is where our highest form of Performing Arts can be seen.

Know Your Audience

Another thing to be aware of is *who* you are going to be performing the drama for. You might have a drama that deals with issues of abuse or drug addiction, but if your audience is children, it will probably go over their heads, and they will not receive anything from it. Make the drama relative to what the audience knows and has experienced!

It's not about performance, it's about the presence of Holy Spirit.

When Jesus spoke in parables, he used examples like sheep and crops, things from the everyday life of the people in his audience. If you are performing for people in prison, the best message for them might be one of freedom and hope. If you are performing for a group of orphans, a message of Father's love and adoption would be relevant. The best thing to do, again, is to ask the Holy Spirit what message he has for the people that will be your audience.

Have a Clear Message

Know what it is you want to say and how you are going to say it. It is better to have only one or two solid themes than lots of good points, especially if the drama is short. What you don't want to happen is people walking away thinking, "What was the point of that, exactly?"

Writing a Story

There are four basic elements to any story:

- Characters - who are the characters in your drama?
- Setting - Where does the story take place? What are the circumstances surrounding the plot?
- Plot - What is the problem to be solved or the question to be answered?
- Resolution - How is the problem solved or question answered?

Some Things to Think About...

If you are performing in a place that is noisy or where it is hard to be heard, it might be best to do a mime or drama without any speaking. This can be particularly effective if it is set to music, as the music can be played loudly and draw people in if it is a large crowd or on the side of the street. A good example of this is the Lifehouse "Everything" drama. You can view it at: http://www.youtube.com/watch?v=cyheJ480LYA

As with any team, the more the team is connected in unity, the better the outcome will be. In drama, the team must learn to *trust each other*. Acting is often vulnerable for an actor, but it is vulnerability that can make a performance convincing and real for the people watching. If you don't trust the people you are working with, then you will not feel safe to be vulnerable with them. It is important especially for the leader to create a safe place where taking risks and stepping outside of your comfort zone is normal.

We have a high priority to have people intercede for the actors while they are performing. Acting can be such a vulnerable place, so it is important to make sure your team is covered in prayer! This can also allow them to focus on the story they are trying to tell, rather than worry about what is going on in the spiritual atmosphere around them. With my teams, I will often gather them together before they perform to invite Holy Spirit to rest on them and to speak through them, then stand at the back of the room during the performance and continue to release the presence of God in the room and around my actors. One time I had another person do this with me. Afterwards my actors told me that as soon as they stepped onto the stage, they could feel the presence of God. They felt Him so strongly that it was almost difficult to concentrate on what they were doing.

One of the most fulfilling experiences I've had is performing with the awareness of the presence of God. It is like I am partnering with Him to tell a story, and with each word I speak, I can feel him speaking through me. It doesn't always happen, but when it does, it is beautiful. It is fulfilling both for me because I get to partner with God, and for the audience because God is speaking through me straight to them.

ACTIVATION:

Write a drama based on these questions:
- Who is my audience?
- What does Holy Spirit want to say to them?
- How can you best display this message through:
 Characters - Plot - Setting - Resolution

(Written by Tiffany Christensen)

Tiffany has given you so much great input into prophetic drama. Right now, she is putting on a full-length drama production at Bethel, which will not only touch the church audience, but also people who are in our community. We need to think about how the dramatic/performing arts are a springboard into the hearts of all kinds of people. I have been involved in writing and directing plays for over 17 years. My family and I would write and put on dramas, which we performed in many of the Nevada and California state prisons and orphanages. When I married my husband, Kevin, I continued to write and perform dramas, mime, and theatre in our church and community within the Southern California area. Drama is such an important part of touching others both within the Christian and secular realms of society. I believe that it has power to bring people into a place of knowing God's heart, which can open them up to hear His voice in a way that can surpass the normal ways we share biblical truth. We are also learning not to limit God by what we have seen in the past through drama. Drama can also touch other countries because it has the power to cross language and cultural barriers. For instance, Heidi Baker uses the Jesus film to touch hidden tribes in Mozambique. Even now God is stirring up His writers to pursue dramatic writing so that we can be the influencers and revelators in Hollywood! Like a Daniel into Nebuchadnezzar's house, He wants to send us where we can interpret the dreams of those who are influential in the arts realm!

MUSIC:

Prophetic music is such an incredible tool to use out in the marketplace and in the church! One year, our prophetic song group went to a conservative Christian college during a harvest festival and brought their guitars with them. They formed a semi-circle, and would invite one of the students from this college in the middle and then the group would sing out their destiny and how much God loved them. As I observed the group, I noticed that there were nearly 20 people eagerly waiting in line to get sung over! We have gone to other countries, released it in the church, and out in the parks. Everywhere we go, people get rocked by how songs, melodies, and notes leave a lasting impression on those who would normally be resistant to stop and be touched by the love of God. We have seen salvations, physical and emotional healings, and incredible freedom brought to people as they simply hear the heart of God proclaimed over them in song.

Everywhere we go, people get rocked by how songs, melodies, and notes leave a lasting impression on those who would normally be resistant to stop and be touched by the love of God.

WRITING:

Currently, Bethel is becoming a media and resource center through iBethelTV as well as through the books and resources being published from our staff. God gave Bill Johnson, our senior leader here at Bethel, a word as he contemplated his desire to touch others through the written word. It is found in Habakkuk 2:2: "Write the vision/revelation; make it plain on tablets, that he who reads it may *run*." Every time we record what God is doing here at Bethel, others have access to those truths and revelations, because we are writing down the testimonies and are broadcasting them live! I have another intern, named Adam Short who (in partnership with another BSSM alumni,

named Graham Morris) has developed an online community called "The Healing Herald" for recording healing testimonies and building a legacy of the goodness of God to transfer from generation to generation. People from all over the world are able to write and read testimonies of God's healing power. (See Additional Resources for Cultivating a Kingdom Lifestyle.)

The Holy Spirit is stirring up a new level of boldness in God's people to reveal the life of heaven through dramatic scripts. There is a passion He wants to impart to us through dramatic declarations written with the Holy Spirit and then acted out. As you read the following section, written by another one of my interns at Bethel School of Supernatural Ministry, named Caleb Matthews, allow the Holy Spirit to release the depths of His creativity in you!

All of us were fashioned and born to embody the language of the universe. With each step we take and every movment made, through us God is honored and represented. It was always His plan that His children would reflect the realties of the unseen world ." So God created man in His own image, in the image of God He created him; male and female He created them.(Genesis 1:17)" We are the physical manifestation of the greatest dream that ever was, ever is and ever will be. Living treasure in jars of clay. The Holy Spirit is the greatest theatrical director we could ever have and *He* lives inside of us! So how do we personify in drama the One burning inside of us like a raging fire? Throughout my life, understanding the power of "the sanctified imagination" has been crucial in helping me become a wineskin for the outpouring of heaven's creative resources to flow freely. "Set your mind on things above, not on things on the earth.(Colossians 3:2)" God will always be faithful to paint His extraordinary plans upon our minds so we can conceive them into reality. Often I will wait upon the Lord in quietness and stillness with tranquil soaking music playing. If Elisha called upon a minstrel to stir up prophecy in Him under the Old Covenant, how much *more* will we receive when we position ourselves under the fountainhead of the New Covenant? The Holy Spirit is the fountain of life and from Him comes rivers of expression! Sometimes in other situations I will begin to write and the words flow like a rushing river. The Bible tells us to open our mouths and He will fill them. There are numerous times when I don't have any ideas or plans on what to write in my mind, but my heart is yearning to speak and be fully understood in the natural realm. Drama becomes personal when we mix our creative hands with our expressive hearts! Every corner of the earth rejoices at the thought of the day when the "pilgrims of expression" voyage into their lands. Our words on dramatic display have the capacity to shift nations, destinies, and history. Will you brave the summit of supernatural illustration? Take the leap of faith, step off the edge, close your eyes and imagine a world where nothing is impossible but everything you dream is achievable. Enter the realm where restraint is extinct and faith is the currency! Capture what you see and when you possess it, begin to build an army of expressionists around your drama piece. Whether by yourself or with a group put action to what you have created. Let your hands, feet and body be free to express the words which you have formed. The world is waiting for your manifestation. All of creation groans and waits...what will you do now? The rest is up to you and God! (Written by Caleb Matthews)

FASHION:

Last year Jessica Akers, an intern in our School of Supernatural Ministry, did a personal project in our arts Track (In our Bethel School of Supernatural Ministry, students have chosen to work together in an arts group weekly, called an Arts Track.), where she launched a professional, Kingdom fashion show. This show highlighted dresses made by our students, each dress representing a Kingdom core value that God wants to release into the fashion industry. The dresses displayed creativity, breakthrough, honor, favor, healing and purity, just to name a few. The fashion track designed not only the dresses, but the jewelry, the make up, prophetic dance performances, and the layout and atmosphere of the room. It was an extraordinary display of the beauty and excellence of our God! They now have over 100 people working on their fashion line and fashion show for 2010. God wants to redeem every facet of the arts world. This is just the beginning of what God is going to do in this arena! Get ready, because there will be designer lines that reflect Kingdom core values, so that when people put them on, they encounter the love of God!

PERFORMING ARTS INDIVIDUAL EXERCISE:

As we begin to explore the dramatic nature and DNA of heaven, there are some simple exercises, which release us into how drama through a simple prophetic act can display God's heart and leave a lasting impression. It can be as simple as putting a scarf on a person and letting them know that God is clothing them with His protection or it can be a song that you sing of hope over a person whom God shows you. Take some time and get alone with God, asking Him to fill you and show you that you have the power to transform others dramatically.

Then, ask the Holy Spirit to show you someone close to you that needs a touch from Him today. If you want to become bolder, you can release this on a total stranger. Now, remember the purpose is to release God's love over you and that person. Begin to write down a song to sing, a creative writing piece, or prophetic action to release them into their destiny or bring healing. After you have finished hearing from God and creating, find that person and release what you were given. Ask for feedback on how they were touched by this.

PERFORMING ARTS GROUP EXERCISE:

In a group, pick someone out and put them in the middle, while everyone else is around them. If it is available, have one person bring a guitar or musical instrument and play softly in the background. Now, ask the Holy Spirit for a prophetic act (do something physical which releases the word of the Lord, like miming the action of putting a crown on their head, wrapping them in a blanket of His peace, etc.), song, or dance to call out that person's destiny. Don't be afraid of waiting on the Lord for downloads. Many people have never opened up to the Holy Spirit in this way, so be patient and wait! After you have finished, ask the person what it meant to them.

FREEDOM IN PERFORMING ARTS:

Some people are terrified of singing, writing, acting, or dancing. As they let go of their fears and trust the group, people will get so free, so create a safe place where people can begin to venture out. Make sure that you encourage those who have risked doing this and give them feedback on how it touched the person. If you want to take it a step farther, for all you radical revivalists, try doing this with people you don't know! This will dramatically release more freedom. If you want to go to the next level as a prophetic arts leader or see people get set free, you will need to incorporate this in your training for prophetic arts. It breaks off every facet of the fear of man! Just make sure that you honor those you are learning to touch through this process.

Comments and Testimonies from the Activations:

CHAPTER 10
Prophetic Dance

Dancers of Freedom *Artist:* Theresa Dedmon

The Father is about encountering your spirit
so that it's almost as if something took your breath away.

Along with the many other forms of creative expression, we have seen God use dance as a powerful catalyst for releasing His presence and love. We have seen the edginess of breakdancing fused with professional dances as a way of reaching the community. Bethel has had dance teams for years with an excellence both in skill and in being led by the Holy Spirit. They are a perfect example of how skill, anointing, and practice can bring beauty and God's Kingdom to earth. At Bethel, we often use prophetic dance as a form of worship to the Lord but also in the marketplace as a way to reveal God's heart for people and see them transformed! The following chapter was written from a priceless interview with Sheri Bukowski, who helped to lead our Bethel School of Supernatural Ministry Dance Outreach team, and has an incredible heart to see God move upon people through the power of dance. As you read her interview, let God stir up your faith for more of what's possible in Him!

DANCE CAN REACH MANY TYPES OF PEOPLE!

I was involved in the prophetic arts long before I would have ever called it that. Before I got saved I wanted to be a back up dancer for Janet Jackson. When I got saved, I had no idea how dance could fit within God's world because there seemed to be no place for dance in the church. It felt like a fight between dancing in the world and going to church, or somehow balancing that so that the two could come together.

We have seen God use dance as a powerful catalyst for releasing His presence and love.

I'm a street dancer, a hip hop dancer and I've also done jazz and ballroom dancing. I appreciate and value all styles and kinds of dance from more liturgical styles to dancing out in the community. I started dancing when I was in middle school but have never really had much formal training. I've learned to dance from dancing with friends, watching TV, doing dance aerobics videos but I have only had one true dance lesson in my life! When I was 17, my friend and I were both really strong Christians but had this very strong desire and insane love for dancing. We would dance in different places in the city but couldn't find an outlet for this in the church. I knew in my heart that I needed to dance just for myself. It was such a strong desire in me that I had to find a way to get it out and spent a lot of time just dancing on my own. I would dance alone in my room and didn't have a need to be on a stage or up in front of people. My friend and I started dreaming about what it would be like to have a Christian musical that wasn't cheesy. We put our dreams into action by creating a hip-hop ballet that went all over Hawaii. We gathered lots of young people together and used both secular and Christian hip hop, jazz, and other music genres. Later, someone in my young adult group approached me about helping to co-lead a dance group. I didn't want to, but I felt like I should, and I ended up leading the entire team. I wanted us to have such a *spirit of excellence* that we could walk off onto a Broadway stage, a TV show or a comedy club and not have people know that this production came from an amateur Christian young adult group. Because I didn't feel equipped to lead this group I would often cry out to the Lord to help me! God would pour out His presence on me during those times of seeking Him. Most of the time I entered our practice sessions so filled with the Holy Spirit that it was hard to even be composed or focused (like the "drunkenness"

experienced in Acts 2). This was my first introduction to a revival culture and the production really took off. People in our group got launched into dance and the production itself kept being performed for a couple of years.

After this, I eventually went to college and then ministry school. I knew I wasn't competitive and didn't have formal training. These two things are really set against you if you want to dance in a professional setting. I simply just loved to dance! So I went to a gym and came up with the idea that I could teach a hip-hop dance class for them and did so in exchange for a membership. This also gave me free access to a dance studio where I could come and dance any time I wanted. I was just beginning to understand the concept of prophetic art and how God can move through dance to impact others. I put together dance routines for this class and, surprisingly enough, instead of mostly young adults- my class was made up of women and men from their late 20's through their 50's. One of my dreams for this class was for people to experience freedom! I had a desire for women who were uncomfortable with their body to go home and feel comfortable about their bodies. I had an older man come to the class who told me that he never really knew what his body was doing but he just felt so happy and free during the class that he had to keep coming back. Others in the class would go home and try to teach the routine to their spouses and that created a time for the two of them to bond together! The class also gave me the ability to relationally connect with people and then prophesy, pray over them, or even interpret their dreams. At times, people would just break down crying as they were touched by the Lord!

One of the women who took the hip hop aerobics class was a middle school gym teacher and she asked me to come and teach her students. So for the next 3 or 4 months I taught over 100 kids dance routines during their class time that they later performed for their school! These kids were great dancers and this was also a great opportunity to speak into the lives of these students while building a connection with them around something that they could relate to. I wasn't dancing in our school of ministry at the time, but one specific day, the Holy Spirit really impressed on me that I needed to bring my dance shoes to school. I started dancing in the back of the sanctuary and ended up dancing on stage with another student in front of our whole school. The other students and I were wearing the exact same colors and felt like the Lord led us up in front to do warfare through the dance.

The following year, Theresa Dedmon asked me to lead a dance outreach in our School of Supernatural Ministry. We gathered street dancers, good spontaneous dancers and also prophetic dancers. Because this was a new thing, we knew we needed to pray a lot, declare a lot, and just be free to experiment! We went out into the city and just danced and talked to whoever came up to us as well as released prophetic words over specific locations in the city. One particular time, we were breakdancing at a skate park and all these little kids were really drawn to what we were doing. They all wanted to learn to break dance and wanted to show us what they could do! One father told us that he was shocked how much his son had come alive when he saw them dance because he was

normally a very shy and quiet boy! However, when the boy got around our team he became the center of attention and loved it. Through this we were able to build relationships with several of the youths at the skate park .

On another occasion, a group of us gathered together to spend time dancing creatively. The leader would call different people out to dance and, as each person joined the group, their dance created a story. There was one woman there who seemed like she was not doing well at all and I could feel something come upon her that made her shut down and turn dark, mad and bitter. Then I had a vision of us all dancing around her and breaking this thing off of her. Sure enough, this woman was called out to dance but, instead of dancing (and she was a skilled dancer) she just sat on the floor and covered herself with scarves. Then I was called out to dance and I had never danced that fiercely in my life! Later that night, as we were leaving, she told me that, she didn't know what had happened, but something had come over her where she just wanted to die and was thinking about killing herself. So we as a dance class were able to break off the spirit of suicide that was on her without ever speaking a word!

Another time our dance outreach team danced at a women's rehabilitation center. We didn't have any set plan or even any coordinated music but, as soon as we started, the flow of the Holy Spirit began to kick in. We only had a very small place to dance so we couldn't have more than 1 or 2 people dance at a time. I could feel different shifts taking place and the Holy Spirit would lead me to who was supposed to dance at what time. I kept sending out and calling back different dancers as the Lord led me. He completely conducted our entire time and everyone had a blast! Some women were crying while others felt the presence of God come on their bodies. A few weeks later, one of the outreach leaders got back to me and told me that they had been ministering to these women for several months with not a lot of breakthrough. However, after we came in, something shifted and they started experiencing major breakthrough as the women started getting saved, healed, and delivered! You could say this was just a coincidence, but I believe that something broke open in the spirit. I believe that all the things this team had been doing to minister to these women had been stored up and our dance kicked the dam out of the way to release those things onto them! It cleared the airways so to speak.

> *Dance is important because of what it does in the unseen realm as well as the visible realm.*

Why Is Dance So Important?

Dance is key because of what it does in the unseen realm as well as the visible realm. People are meant to move and our bodies are meant to move to music, rhythms and beats. God wouldn't have given you the *ability* to move to a beat if He didn't expect you to move to a beat! God set something in our DNA that makes us want to move and be creative. A lot of people don't let themselves do this, but if they would let themselves move in this way, they would find that they can let themselves follow the Spirit!

When we release dance we are also breaking things open in the spiritual realm. Like when we

speak in tongues, we know that every time we create, something is released in the spirit! Sometimes we have the interpretation, and sometimes we do not; but either way, we know that Holy Spirit has released something through us that will bring about change in one way or another.

Every time you dance, there's a need that that dance is meeting. In the Bible, people danced before victory and after victory. Some dance out of worship, some out of radical abandonment to the Lord, some out of celebration. The most important thing is to tap into what the Father is doing, or the dance will be ineffective. As an audience member you can appreciate skill, choreography and talent, but those things in and of themselves won't move you in your spirit. The Father is about encountering your spirit so that it's almost as if something took your breath away. These concepts apply to every other form of art as well! God wants the arts to so impact us that we are actually mentally, physically, and spiritually changed by coming into contact with them!

A Word About Prophetic Dance in Teams

In all areas of the arts but *especially* in the performing arts, you absolutely must have a *solid* team dynamic. This means that if you have to have time just to focus on your team, then please take that time because *unity commands a blessing!* If you don't have unity, then you may look good on the surface, but there will be a hold up in the spirit. Sometimes our team would dance and we'd feel disconnected or there'd be quarrels between us, and it really affected what we did. It can sometimes be hard to get creative people to focus, so it's important that you both honor people's individual ideas yet keep them focused for where you are going as a team. Leaders must have a very strong ability to have a focus but also be able to appreciate people's ideas and input. They need to not be so focused on what they want to do that they don't stay open to the ideas of the team and what the Father is doing through other people.

Dance Inside & Outside the Church

There's dance that you can do in the church that will release a message and bring a lot of freedom, and then there's dance you can do in the street. The two look *very* different. I don't think they need to look alike. The Body of Christ needs freedom and exhortation but people in the street need to be drawn into a relationship with God that many of them do not already have! It is rare that you can take a dance that works well in the church and bring it out onto the street and have it be as effective. Usually the Father is doing something different with both groups of people.

The Role of Dance Within the Church

Dance in the church can be a time of worship where we lift up our hands and exalt the Lord. Or it can also be a time of simply moving with the spirit even if we don't know exactly what we are doing or why we are moving that way. At the same time, dance is also a trained skill where we can do choreography, have times of practice and have things that are like a performance. No matter which way we experience dance in the church, it is still bringing just as much freedom to the congregation as to those who are dancing.

Whoever is overseeing a dance program in the church needs to know that there will be people who feel called to dance but have absolutely no skill or training! This has to be honored, and leaders need to balance the *call* a person has on their life with their *practical skill level*. Nevertheless, those who have a passion and hunger for dance should be encouraged to partner that hunger with practical training to increase their skill. Dancers should be willing to be trained because there's an tremendous power that comes when a person is both trained and anointed. There's a point where your natural ability has to, at some point, correlate with your call. It's about *stewardship*. At the same time, there can be a person who cannot dance at all but has such an anointing on them that you know they need to go up front and dance in worship that day! They may even look like a fool but they carry the presence of God and ushering in the presence of God is what matters above and beyond skill level. Likewise, you may also encounter people who have an incredible skill level and ability but their spirit is not lined up with what the Father is doing. Their ability cannot not trump what the Spirit is doing so there just needs to be a fine-tuned sensitivity for how to balance this. When you're dancing in a church setting on a stage and partnering with worship, there needs to be a very fine-tuned sensitivity to the Spirit. Again, this brings up the importance of really taking time to personally connect with each other as a team. Leaders also need to train people how to worship with Holy Spirit and not be afraid to walk people through that over time.

A Note to Pastoral Staff Who Want Dance to Be Released in Their Church

Always honor what God is saying to the leadership team. The most important component that we have found is building up people who oversee the dance who have the same heart as those who are in leadership. Bethel has a company of dancers who are a strong team, and who know the core values of Bethel. This team dynamic is one of the reasons the dance is so successful during conferences and evening services. We have worked hard to bring excellence to dance as well as be led by the Holy Spirit, incorporating various different styles of dance. If you have a hesitancy about starting this, find out if this is from a personal fear or if it is just the timing element in raising up the right leaders to oversee this kind of ministry who carry the heart of the church leadership. Also, having people practice in their *alone* time gives them authority in the *corporate* times.

Honoring Your Church or Outreach Leadership Team

Make sure that you commit to *supporting the vision* of your church and pastoral leadership team! If they have a certain idea about the dance, support this. Find out first how you can come under their leadership and then as trust grows, share ideas that you have. Make sure you communicate what you will be doing in the dance and what dress is appropriate and what they are looking for. Dance can be one of the most releasing things for people, but it can be one of the scariest ventures for pastors if you release types of dance or dress that go against the core values or mission of the church leadership's beliefs.

The Role of Dance Outside the Church

Most of the time, dancing for outreach will look very different from dancing within the

church. When I picture dancing for outreach, I imagine people on a street corner dancing, putting on a show, or going into a school. Skill, excellence, and quality are key. It's also very important that you have something that is really relevant to people on the street. For example, a lot of churches may not do much with hip hop music but, out on the street, it's something that a lot of people can connect to.

For people on your team, street skill is useful and it's important to develop an ability to be bold and build rapport with people. Of course, people still need to be connected to what the Father is doing and not just be putting on a show! The Holy Spirit can trump anything. He can take someone who knows nothing and save a city. He can do whatever He wants to do and God will use very messy people. Even if they aren't the most sensitive to the Spirit. In street evangelism, it just takes people with shameless audacity, someone who can draw a crowd and be okay with being the center of attention. The world recognizes talent first but that only goes so far. Their attention span is very short. So talent may draw them in but it's what *the Spirit* is doing on that person with talent that is going to really touch them and change their lives!

A Note to People Who Want to Dance Professionally in the Secular Arena

When we're going out into all the world, the Bible tells us that we are to be shrewd as serpents but innocent as doves (Matthew 10:16) . We have all authority but you are still entering a realm that does not recognize the world (the Kingdom) that you live in. I think a person needs to possess an ability to be in the world, have the skills the world expects, have the abilities the world demands, the excellence, the training, the professionalism, but always know that they are called by God. Always know that even if you never said anything about Jesus or had an evangelistic meeting, just your presence will change the atmosphere around you. When you can be in the world but yet not be part of it, like Daniel was, then God will open up doors and His kingdom will come! There will be healing, salvation, and deliverance because that is the nature of the Kingdom and that is what you are releasing! People who are called to be professionals in the arts realm need to be so secure in who they are in the presence of God that, when the presence of God takes on a different form outside the church than inside the church, they're not concerned. They know the Spirit is moving even if it looks different with different people at different times!

I find that when Christians go into secular places and try to make it look like church, then we've lost the true understanding of what the Kingdom is. If we try to make the world look like the church that is when the world shuts down because their needs corporately are different than the needs of those inside the church.

Dance in the Nations!

No matter where you go in the world, the arts are an epicenter of culture! It is through the arts that we tell stories; it is how we depict wars, how we celebrate, and how we mourn. Any form of art

– whether it be painting, drawing, dance, sculpture, drama or music - is one of the most significant and powerful ways that laws, cultures, systems and beliefs have been translated over generations. In the past, people didn't speak a common language and historically most things weren't written out but people danced out their stories, memorized poetry, sang songs about their tribe or painted their journeys on walls. Art is the universal language that God moves through every culture in the same way, yet with different expressions. When we talk about the "prophetic" we'll often say that English (or you could think of your primary language) isn't God's first language. We put words to things, but God speaks through pictures, signs, numbers, colors, coincidences, etc! There is no form of art that is "correct" and therefore one culture cannot go to another and tell them that they need to change to be like them in how they create. We can share ideas and breakthroughs but ultimately, each people group will release their own unique artistic DNA both as a national group as well as individually. People created cultures but God's Kingdom is over every culture. So when we go from one culture to the next we don't have to rob them of their cultural identity in order for them to enter into the Kingdom of God! Historically and culturally, dances originated out of something, whether political movements or historical events. Slaves danced to mock their masters or to express frustration. Native Americans dance as a prayer and have movements that mimic different animals. Flamenco dancing in Spain tells the story of the matador and the bull. In Hawaii or Tahiti some of their dances mimic waves crashing on rocks and are in honor to their gods. Other dances are for fertility, or warfare, or about different relationships. To the pure all things are pure. So when you *carry an atmosphere* of purity you can release Holy Spirit into arts

> *Dance can be one of the most releasing things for people.*

that may have even been rooted in something else! In the prophetic, if we see something negative, we'll prophesy the opposite of it. So also we can release an opposite spirit to indwell dances or other art forms that may be rooted in something that is not of God and therefore redeem the art form instead of tossing it aside!

ACTIVATION EXERCISE: INTERCESSION DANCE

Either in a group or individual setting, pick a subject or person dear to your heart that needs breakthrough. Then, start to dance, asking the Holy Spirit for prophetic ways you can release breakthrough to this place. After you are done, write down what you felt God did, and find out how things shifted in the heavenly over these situations.

If you have a heart for dance, begin to minister privately with God and intercede for ways God will open up for you to fulfill your heart's desire. There could be all kinds of opportunities in the marketplace for you to begin to branch out into dancing. Again, practice and training are key areas. You may want to take a class or join a group. Begin to activate your call by positioning yourself in places where you can grow in skills as well as anointing!

TESTIMONIES ABOUT ACTIVATION EXERCISE IN DANCE:

CHAPTER 11
Prophetic Arts in the Marketplace

Crowned by the Father's Love *Photographer:* Student of Veien Bibel Skool

We are starting to understand that the more we embrace God as the infinite Creator of all music, sounds, dramatic ideas, fashion, creative culinary ideas, and film innovations, the more we will have to give to the world around us!

This manual is all about how the arts can shift and change not just the church, but the culture around us as we learn how to partner with the Holy Spirit. One of my greatest joys has been to see how hungry our secular culture is for what we know about God as they identify with the various art forms. Pictures get into places where preachers can't. Dancers and music draw a crowd faster than tracts given out on a street corner. Children will race past other amusements to get a balloon crown that calls out their destiny as a princess, or a balloon sword where they are knighted as a prince. Why is this so? People are desperate for God's love but in a way that they are familiar with. We have to understand how they are wired. We all were born with an insatiable desire for creativity. Our voices, minds, bodies, and spirits were meant to worship God with everything we have! (Romans 12:2). We are starting to understand that the more we embrace God as the infinite Creator of all music, sounds, dramatic ideas, fashion, culinary creativity, and film innovations, the more we will have to *give* to the world around us! We have the awesome privilege of re-presenting Jesus! Let's find out what He is up to as He looks at us!

As I started on this journey in leading prophetic arts, one of my targets has been to transform geographical locations. For instance, Redding is a place where Jesus loves to go, and I like to show Him off through all the creative expressive forms, which bring a culture of life, because He *is the life*. We are meant to bring Jesus as the life of the party into the celebration times where people live and hang out! When Jesus went to the wedding of Cana, he wasn't off by himself, but He was providing the wine! If you were to interview people in the city you live in, most people would say that God is not fun and is unhappy with them. Guess what? One of our greatest privileges is to set the record straight and to throw the biggest party this world has ever seen, not in the church, but *outside through* the church!

I would like to share with you a story about what happened with a student in our school of ministry who went out to touch the homeless with prophetic art. It was this student's first time in drawing a picture for someone, and the man who came to her just happened to be homeless, unkempt, dirty, and depressed. It took all she had inside of her to sit down and just say hi. As she looked into her box of used oil pastels, there were only neon colors remaining so she decided to draw him with what she had! As she did his portrait, she felt like the Holy Spirit wanted to draw him as smiling, drawing out the opposite of what she saw in the natural. After she gave it to him, she told him that God saw him as happy. He looked perplexed, because he had always thought that God was angry and disappointed at his lifestyle

> *People are desperate for God's love but in a way that they are familiar with.*

and alcoholism. She said that he was mistaken and that God loved him just the way he was. Then she left, not really knowing the full impact this picture would have on him! This man was then picked up for our Sunday morning services at Bethel from the Rescue mission. As he rode the bus to the church, the homeless man showed the picture she had drawn for him to the driver, and explained how he couldn't believe what she had said. He then wondered if God could heal him because he had a cold. The driver said "Absolutely!" and told him to ask God about that during the worship service. So, as worship started, the homeless man asked God to heal him. He felt something happen, so he opened his eyes only to find out that he was *healed of being blind in one of his eyes*! As you can imagine, he screamed out about being healed, which drew the attention of the pastoral staff. They asked him if he had any other

problems and he said that he was deaf in one year and was missing an ear drum. They prayed and a brand new ear drum was created! He also had a hand that was damaged and that too was healed. I had wanted to meet him, but was not attending that particular church service. However, God always seems to fulfill the desires of our hearts! Two months later, Bill Johnson was preaching and had a word of knowledge about God wanting to heal arthritis. I went over to pray for a man who raised his hand, not knowing that it was the same man! As I prayed, he was healed of arthritis and blurted out that this was just like when his eye opened. I started to say, "You're not the guy that got healed two months ago in worship are you?" He nodded the affirmative. I then asked if he still had the picture. He told me that he carried it wherever he went, because *"once I was blind, but now I see!"* He had linked his healing to the picture which had declared God's love to him when he needed it the most.

Here is another testimony of a man in our community who was touched by the Kingdom of God through a prophetic arts treasure hunt (See Form in Appendix of Prophetic Arts Resources):

During our treasure hunt, one of our team members was a visitor who had come to the writer's conference at Bethel. He had the clue "white tee shirt" written down on his list. As soon as we got to the park, we saw a gang banger standing there, talking on the phone. I just assumed he was "doing business in the park," selling drugs. He had on a solid white tee so we waited for him to get off the phone and approached him with our treasure map to tell him he was God's treasure. Surprisingly, he thought it was cool that we were out doing treasure hunts. We showed him our maps, but there weren't any other clues that matched his description. We asked him if he needed prayer for anything and he said yes. His brother was facing 19 years in prison, and they would find out the court's verdict later that day. His brother and "friend" were responsible for killing a homeless man several months prior. So, we started prophesying over him and sharing Jesus. He was open to hearing but then we got to *really* rock him. As I looked at his right inside forearm, he had a tattoo that looked exactly like one of my "prophetic stick figure" drawings which I had made before we left! I turned my map over and showed him the drawing and he let out a few "four letter words" in amazement! He said this whole appointment was God! He continued that it was a miracle that he was even awake at this time of the day, but that when he woke up, he just knew he needed to get over to the park! For some reason he felt that this was going to be a special day! We continued to share Jesus with him and he invited Jesus into his life! His entire countenance changed in an instant!

We have seen so many places in the city touched through all the art forms. We have done balloon animals and face-painting at bookstores, read stories and done art classes in libraries, wrapped Christmas presents with prophetic cards for Christmas shoppers, performed plays at Christmas and set up art stations in our downtown mall, sang over people prophetically at college harvest gatherings, danced regularly at the skate park, released the arts at blues festivals, New Age festivals, and other community events. We have had our art hung in City Hall, local coffee shops, and businesses. It's just been our belief system that God's love is attractive and that the arts are a vehicle for bringing the real Jesus out on the street corners, local businesses, stores, and homes where people hang out! Maybe this is something that scares some of us because we have never seen it demonstrated, but it gets in places where

people really are! If that's where Jesus is, then that's where I want to be! I am not afraid to learn a new language that is spoken by the masses. Wherever a society has value, this is a place for gospel invasion. I hope you hear my heart and venture out to see how the arts can prophetically transform your city! Take a risk and begin to open your heart to the limitless possibilities and gifts that are waiting to be unleashed! I have had the privilege of training churches on prophetic arts within their community. Here is a testimony from Ventura, California, where we released the arts with Horizon Foursquare Church and our Bethel students:

Are you curious to know how *balloons* can be used prophetically to reveal the love of God and release His Kingdom? Let the following testimonies sow faith into your heart!

During a time of outreach in the city of Ventura, a junior high girl from our team named Julia made a balloon crown and felt like she was to present it to a homeless woman she had seen in the park. She approached the woman and told her that God called her His princess as she crowned her with the colorful balloon creation. The woman was obviously touched and began to cry. Julia then felt from the Lord to tell this woman that God was going to provide a home for her, and declared a prayer of faith over her that this would happen *soon*! The homeless woman seemed very encouraged, and the two said goodbye. However, later on in the afternoon, Julia ran into the woman again and she was *overwhelmed* with joy! The woman explained to Julia that shortly after they had prayed, she ran into a woman who used to be a spiritual mother to her and she offered her a house of her own to live in for three years! Now *that* is how our good Father provides for His children!

Within the very same afternoon, another group of people were loving people through the prophetic arts on the main street of downtown Ventura. We had set up a table offering free interpretive portraits, face painting, and balloons, and at one point, a pair of twenty-something men approached us, each one daring the other to get his face painted! After joking around with us for a few minutes, they finally agreed to let us draw pictures for them, and as we talked, we discovered that they were both in the military and would be returning to Iraq very soon to re-engage in active

God is so eager to release life and destiny over people and draw them to Himself, and He will use EVERY creative means to do that!

duty. We felt the presence of God begin to surround them, and they began to open up their hearts even more and honestly share their fears about returning to the war front. As we continued drawing our pictures for them, one of my pastors sensed that we were to knight them with balloon swords and honor them for their courage. So he asked them if they'd be open to that, and before we knew it, these two men who had first mocked what we were doing, were kneeling on the street corner, crying as we declared the heart of God over them! It was a *powerful* moment! We "knighted" them as sons of the Kingdom, and as they rose to their feet, one of the guys grabbed the balloon sword, and raising it into the air said "For the Kingdom!" (Written by Melissa Cordell)

Doesn't that make you hungry for *more*? God is so eager to release life and destiny over people and draw them to Himself, and He will use *every* creative means to do that! Within our school of ministry, we use many different creative methods to touch the city: prophetic drawings/portraits, prophetic writing, face painting, balloon animals, prophetic song, prophetic drama, and prophetic dance.

Here's another testimony about how a simple prophetic picture can be the open door for God to heal people's bodies and their hearts:

For our Thursday outreach (2/30/08), I decided to take my prophetic arts outreach team to the emergency room because if there's one place filled with people needing to know that they are loved and valued, that's certainly one! We were able to connect with so many people while we were there, and we could feel that as they looked into our eyes, they could see our love was *real*. By far, the most radical encounter we had was with a mother and daughter, Lisa and Crystal, and our connection began simply through a piece of prophetic art! While her mom was seeing the doctor, Crystal had to sit all alone in the waiting room so I asked if we could draw a picture for her, and began to tell her about all the incredible things God had put inside of her. Light came into her eyes, and she was completely astounded when we began to tell her (through words of knowledge) that she loved to dance and sing! When her mom returned, my team and I discovered just how much of a divine setup this was: they had been traveling by bus from Arizona to Seattle, Washington, to escape her abusive husband. They had been longing to break free for years, and when the window of opportunity finally came, they were able to leave but had no food, no money, nothing! Of course, in the midst of their journey, they just *happened* to stop in Redding because Lisa, the mom, needed relief from the intense pain caused by her pancreatitis. As we began to talk with her and her daughter, there was an instant heart connection, and Lisa was so overwhelmed and softened by our love. Though we only got to talk for a short time because someone came to take them to the mission for the night, the adventure certainly didn't end there! I gave her my phone number, and implored her to call me to let me know how they were and if they needed anything at all. The very next day God did more than we could have ever imagined. Since Lisa and Crystal's bus for Seattle didn't leave until 9 PM, and they had no food or connections until then, I brought them over to our house so they could rest. Lisa expressed that she wanted to go to another hospital because she was still in pain from her pancreatitis. I asked her if we could pray for her before we took her and she agreed. As we prayed, there was such an overwhelming sense of God's presence, and all the pain left her body! However, she still wanted to go to the hospital just to make certain everything was all right. So after spending the afternoon with the doctor once again, she could hardly wait to tell me the news: they did a urine test, blood test, and a CAT scan, and could find *no trace* of pancreatitis! So much for "incurable" diseases! The doctor even questioned if she had really been suffering with the disease, to which she promptly replied that she had endured it for over 7 years! This radical display of God's love so filled her with joy and peace that she was overwhelmed with the Holy Spirit for the next several hours. God continued to bless them tremendously for the rest

of our afternoon together. Lisa experienced so much inner healing, and was totally undone by the faithfulness of God to usher them into this new beginning. Everywhere we went, she couldn't help but tell everyone about what God had done! And her daughter Crystal was even baptized in the Holy Spirit, and heard Jesus speak His love and promises to her in the back seat of our car! After saying a long, truly heartfelt goodbye, my housemate and I dropped them off at the bus station, and spent the rest of the drive home completely undone by the love that God was able to release through our lives. All we could say was, "*That* is what we're born for..." (Melissa Cordell)

Here's one more testimony from a team of people who were on a mission to release the true love of God in San Francisco, and the incredible ways the prophetic arts were used to reveal His heart:

This entire trip was so strategic and empowered by the Lord, and we were in awe at His radical grace, love, and goodness that overshadowed our team throughout our time in San Francisco. We knew that above all things, He was calling us to be radical lovers of the people in the city, and that was our heart and mission when we went to a transgender bar on Friday night. No agenda, just to *love* these people toward a revelation of the desire of God *for* them. I cannot even begin to describe the supernatural grace that empowered us the entire time we were there! Nine people from our team spent about 4 hours in the bar, and during that time, one man received Jesus as His Lover and Savior, multiple people got healed including a man whose leg grew out, and countless people told us that they had *never* experienced anything like this love from Christians before! Throughout the time when those in our team were inside the bar, another team member and I were out on the street in front of the bar, creating prophetic paintings for the city, and ministering to people on the street! We had more divine encounters than I can count! Two men driving by suddenly stopped in front of the bar, *shocked* that I was painting on the street at 10:30 at night! We got to pray and prophesy over them, got a word of knowledge for one of them about his back pain, and right then he felt tingling in his back as we prayed! Another man who came by matched a treasure hunt clue from earlier in the day. "Heartbreak" had been on my list, and we got to pray for his heart to be healed from a painful relationship split. He had come from Sweden to San Francisco, drawn by the city's promise of community but had been left alone and hurt. However, we got to show him that *God* saw him and loved him! We also met the most incredible, Spirit-filled, Jesus-loving homeless man! He prophesied the meaning of my painting before I'd even finished it and couldn't stop praising Jesus for us being there! He kept telling me over and over, "I've been *praying* that people/artists would come and do things like this!" At one point, in awe and worship of Jesus, this man took a ton of costume jewelry that he had in his suitcase, and *threw it at my feet*. I was so blown away as he released his adoration to God. But about 30 minutes later, something even more profound happened. Two transgender women came out of the bar and began to talk with me about my painting. Then one of them noticed all the jewelry and said "Is this yours? May we have some?" I told them "Yes, of course!" And they proceeded to take all the jewelry that he poured out on Jesus in worship, and *put it on themselves*! They adorned themselves with that which was given in love to

Jesus! I was stunned! More and more of that sort of thing happened throughout the entire night. I planned a second painting. It was to be the silhouette of a male and female figure (representing Jesus and San Francisco) about to kiss, with the words "Grace and love, like mighty rivers, flowed incessant from above – Heaven's peace and perfect justice kissed a guilty world in love" written across it. As I began to paint the very basic outlines of the people, a beautiful woman off the street suddenly came up, talked to me for a minute, and then proceeded to commandeer my paintbrush, and painted the *entire* painting herself! She, representing San Francisco, depicted His love and radical devotion to her! And then, for the icing on the cake, just as I finished writing the words on the painting, a girl I had met earlier (who was *really* under the influence of drugs and alcohol) came by again and read the painting *loudly*, almost proclaiming it, for everyone on the street to hear! I was beside myself with awe to hear the desire of the Lord released over them *through her*!

Finally, at the end of the night as we were packing up our supplies, a woman named "Marisela" began asking me about one of my paintings – she wanted to buy it but I said that I had painted it in love for her and the city so I wanted her to have it for free. I don't think she really knew what she was in for or if she had read all I'd written on the painting but she joyfully received it, and even wanted us to take a picture together holding it. After a loving hug and kiss on the cheek, she walked down the street carrying a soon-to-be-life-changing encounter with the radical love of Jesus. The painting read, "Do you know the way you move My heart? I love you – I want you – I choose you, San Francisco! I'm not disappointed, I'm not angry, *I'm in love with you*! This is the heart of God." (Written by Melissa Cordell)

FINDING WAYS TO TOUCH YOUR CITY

Value and Need

When I first began to reach out to people in the marketplace, I fell in love with them! I started singing in rock and roll bands, where we would change the lyrics so that people could hear about God in songs that were familiar to them. I was singing Cheryl Crow songs in the worst parts of LA, and watching hundreds of people come to Christ as my husband, Kevin, played drums. I was a dancer in a Christian rap group in downtown Huntington Beach, which drew crowds of people. I used mime and drama on the street corners and in the parks as we set up outreaches throughout the greater LA and Orange County area. As I began to hear their heartbeat, I noticed that no one was ministering to the children, so I set up a place where we could minister to children through different art forms like balloon animals, face-painting, writing, and other ways. I linked in the major events and holidays in our city and created outreach events, and found tons more people to touch. My husband and I taught our people to create a party atmosphere where we would set up a barbeque with free food, a trampoline for kids, a band with music, and fun for the children in the arts. I won awards from the city for my involvement in blessing and touching the city.

After we left our church and moved to Bethel in 2002, I began to see how I could prophesy through all of these art forms, which I had used in outreach at our previous church, where we were senior pastors. After I came on staff at

Bethel church in 2003, I began to introduce these concepts into our outreach program; thus prophetic arts outreach teams were birthed! We now train around 600 of our students to reach out to others through the arts.

How can *you* start a movement of prophetic arts where you live?

Create a Team

First of all, find out what your pastoral staff's vision is for the church and share with them your passion. Begin to partner with what they see!

After you have done this, find people who genuinely want to reach the city and begin to partner with them. Discover places and things you or your team would like to do in order to bless people. Partner with local businesses or other churches if you can. Then, create an atmosphere where you would like to be, bringing joy, celebrating the people in your city, and loving them as Jesus loves them. This is how San Francisco was changed when Melissa's team went to the transgender bar, and this is how other cities will be changed throughout the nations!

Stewardship

If you are going to start touching the city, you have to have a broad-range vision and be consistent, so that people begin to count on you. Your city will know you by the love and attention you give it, not on a one time basis but over the years. So be encouraged! Every seed you sow, if watered, will produce a rich harvest for God! I would encourage you to set up places in the city where you can sow into the people and area on a consistent basis so that you will have lasting fruit. Find the places where you have the most passion, start small, gather a team, and then watch it grow!! God loves to hang out with those who love His sons and daughters right where they live and hang out. You will find parts of Jesus here you can't find in a church service or in a home group and you will find that God is equipping you to go, because you have the supernatural power to walk as He did through the marketplace.

Learn Their Language

Build rapport with people in the community. Be real, not religious in the way you talk. The best approach is to let them know that you are just stepping out and beginning to use this gift of art and ask them if they have a few moments to sit down and be with you. I usually make small talk and smile, giving them a love encounter and seeing if they are open! Many times, it can be easier to go with one or two other people so that you feel more supported. You can also use the prophetic art treasure map we've provided for you (See Appendix of Prophetic Arts Resources). It's great to partner together as families, church or youth groups as well!

Also, share your testimonies with the people around you and the hunger will grow and pretty soon, you will have a mighty team around you, hungry for God to give them more ideas in creativity to change their city and love on the people you have been given.

ACTIVATION EXERCISE:

Ask for God to give you a vision so you can begin to step out and touch your community. Ask the Holy Spirit to give you a picture for seeing that area transformed. What would you like to see transformed in a year, two years, and in 10 years within your city? Then start with prayer. Ask God for the blueprint for transformation and then begin to venture out and do what He shows you to do! It's interesting how God has used a need that I saw to motivate me into action. What needs do you currently see in your hometown? What do you have personally to give? The first steps don't have to be big. It could be singing over people prophetically at a convalescent center or doing an art piece for someone at a coffee shop. The point is that you you have something to give, so find a place where there is a need and begin to implement what God shows you.

Write down here testimonies you or others have done in your community:

CHAPTER 12
Prophetic Arts Supernaturally Impacting the Nations

The Eyes of Mexico *Artist:* Theresa Dedmon

We are about to see the prophetic call of nations now come to the surface so that the Arts from each people group can reflect not only how God has made them to be as a people, but what His destiny is for that particular people group.

God now has broadened my path and our BSSM students are seeing the arts prophesy to the nations as they go out on trips around the world! As I have mentioned before, prophetic arts is like a modern-day version of the gift of tongues in Acts 2 , where people see who God is through a grid they can identify with in their own culture. Reaching out to other countries through the arts will draw crowds of people to Christ! The power of music, art, media, drama, fashion, music, and dance, as well as other artistic expressions, are what define a culture! If we can re-present who Christ is through these different art forms, we will see tremendous fruit in our desire to touch the nations for God.

As a people in revival culture, we are learning to follow the Holy Spirit. We are now seeing healing break out all over the world. We are about to see nations step into their prophetic calling so that the arts from each people group are a reflection of their identity and destiny from God as a people! When I went to La Paz, Mexico, I taught the people in the church a basic drama, which they then changed into a form that would relate to people in La Paz. As they performed it on the Maleton Beach area, hundreds of people gathered to see Jesus speak to them *from their own culture.* At this time, people were getting healed, prophesied over, and saved! Many in the church knew the people down there and connected with them in a way they had never done before!

When I led a mission trip to Bergen, Norway, last year, we were able to release the power of prophetic arts both in their church and in the marketplace! Here is the testimony of what happened through the voices of the church leaders we partnered with to see God's Kingdom come!

PROPHETIC ARTS BLITZ NORWAY!

Present-day churches all over the world have caught wind of a growing new renaissance called Prophetic Arts. Curious about its value and purpose, many have wondered, "Do the arts really have power to change peoples' lives? Is it possible to release an artistic 'splash' that prophesies, heals and redeems?" The answer to both questions is a resounding yes!

In March 2009, I took a team of twenty imaginative BSSM students to Bergen, Norway, for the purpose of training Veien Bibel Skool participants in prophetic art. Prior to the training they received from my Bethel School of Ministry team and me, Sverre Bjørnhaug and Fredrik Skoglund, leaders of Veien, weren't certain that art could make a significant Kingdom impact. Recently, however, they both shared with me that in less than a year's time they have been thoroughly convinced by a regular stream of testimonies! In fact, prophetic art has been so effective that their Bible school has now incorporated the arts into street ministry wherever they go!

In addition, believers have also discovered the power of declarative prayer and explosive praise and worship using prophetic art within corporate worship times. Gifted artists in the body have also begun using their talents to create and distribute "prophetic art" through saleable products. One of those artists has made a calendar that proclaims God's royal identity for the women of the nation of Norway.

Impacting Prophetic Art Testimonies

Sverre and Fredrik shared a few prophetic arts testimonies from Veien Skool outreach team experiences. Each story reveals the passion of the Holy Spirit to convince people through creativity and beauty that God is good and He loves them deeply! Hold on to your hat and listen to these fresh testimonies of the Spirit's artistic inspiration blowing through the country of Norway.

Taxi Cab Drawing

In the city of Stavanger, we trained members of a local church in how to create prophetic art to take out into the streets for a day of outreach. One participant asked the Holy Spirit for a picture and then sketched a rough image of a yellow taxi cab going up to heaven. Searching for the person whom God was highlighting as his divine appointment, he nervously approached a man and his son. He then shared his art piece with them and explained that God wanted them to know He was interested in their lives. Amazingly, the man he'd approached was a taxi driver, who was stunned that God would care enough to send proof of His love through the prophetic drawing. The taxi cab he had drawn was going up in the air and so the man asked why he drew it this way. He responded that it was going up to heaven and that God wanted to take him to heaven and give him new life. As a result of the encounter, both he and his son accepted Christ as their Savior!

Curious, Healed, Saved

After I led the team to Norway in Spring of 2009, the Norway School of Ministry went on their own missions trip to Bosnia. While doing outreach in Bosnia, a Veien Bibel Skool team decided to set up and release prophetic art while they waited for their translator to arrive. An inquisitive young woman stopped to watch them and the artists began to minister the Kingdom of God to her. Through their prayers, she was healed of a physical infirmity and gladly received Christ. Art drew her heart into a "God encounter"!

Pianos and Flowers

Sverre, the head of the Norway school explains why prophetic arts is so relevant in reaching the lost in Norway. Approaching a stranger to speak to them about Jesus is fun when you're able to give them a gift of artwork. With art as a point of contact, religious overtones of our interactions with individuals are set aside, and they won't feel we're trying to "make a sale": it's one of the new ways of reaching peoples' hearts in Norway. One member of our team of believers painted a beautiful picture of a woman playing a grand piano in the middle of a field of flowers. Later that day the artist felt impressed to give the painting to a young lady passing by on the street. The woman was shocked. "You don't know me, do you?" she asked. The painter responded, "No, but I just felt this painting was for you." The woman quickly explained that she worked in a flower shop, but her aspiration has always been to be a concert pianist. She queried, "How did you know this about me?" "God showed me," the painter answered. The young lady was touched that God could possibly speak to her heart so directly and so clearly.

Songs of Salvation

We trained the Norway school of ministry to prophetically sing as well over people in the marketplace. One time, several believers were singing songs together on a street corner. A young woman, partially inebriated, sauntered over and complained that she didn't know any of their songs. She suggested they sing familiar songs, so that she could sing along. With her permission one of the believers sang a spontaneous prophetic song to her, directly from God's heart. Deeply affected, she wept and began openly sharing about her life. Team members ministered to her and she was set free, saved and baptized in the Holy Spirit.

Another team member playfully sang prophetic songs to a teenage sister and brother while on another outreach. As she sang, she identified aspects of their lives she could never have known apart from divine words of knowledge. Both were intrigued and as a result, openly received prayer for physical healing of the sister's shoulder. After her pain disappeared entirely they both invited Jesus into their hearts, but the encounter didn't stop there: team members also prayed for their baptism in the Holy Spirit and declared over their lives God's call for evangelization of others, before joyfully parting ways!

Anointed Art for Healing

Art is powerful as a tool of prophecy, encouragement and healing within the church as well as on the streets. As a Veien Skool team ministered in a local church, several students painted prophetically during worship. One woman present received three separate physical healings during the service and later testified that one of the art pieces being painted during worship moved her profoundly, releasing her to be able to receive her healings. Interestingly, these student painters had never before done prophetic art, but the anointing of the Holy Spirit flowed through them freely! If God can do this in Norway, think what He has planned for other nations as well!

New Arts Renaissance

As I was interviewing these two pastors from Norway 6 months after my mission's trip there, we began to talk about the new Renaissance in the church and this is what we talked about:

All believers can do prophetic art and release the dunamis power of God, whether or not they are naturally experienced in drawing, painting and other media. Every individual needs to personally cultivate a willingness to take risks and to love. Corporately, however, there is one necessary ingredient if prophetic arts are to flourish within a local church body. Performance-based atmospheres that turn inward lack the power of the Holy Spirit, and must be

All believers can do prophetic art and release the Dunamis power of God, whether or not they are naturally experienced in drawing, painting and other mediums. Willingness to love and risk are all individuals need.

replaced with a strong, church-wide prophetic culture that empowers believers to rise up and fly in their gifts.

Creator-God's Spirit is within us. We have His mind and His heart! Let the wells of imaginative expression be uncapped and overflow in the church and into the world, unleashing the heart of our Heavenly Father-Creator through creating sons and daughters.

Until recently the church has had a predominantly one-dimensional image of how God speaks. We've assumed people receive primarily through the written or spoken Word of God, but we're waking up to understand that God communicates to us by using all of our human senses. We're probably more accustomed to experiencing Him through one or two senses, for example, through hearing His voice, or seeing a picture or feeling His presence, but as we open up to other avenues of receiving from heaven, we'll hear God much more than ever before. Impacting all our senses, prophetic arts cut a direct pathway from God to our hearts and expand our ability to perceive heaven's "transmissions."

As the church is able to embrace all of the infinite ways God relates to us, artists from the world will no longer feel they have been dismissed or ignored. History is full of those who wanted to walk creatively within the church as painters, musicians and with other media, but the church rejected their gifts as not being "godly enough." God is waiting for the church to invite the creative orphans back into the family of God, to explore with them how He communicates, to welcome their gifts and to activate them in the Body of Christ.

Divine innovation and inspiration are also meant to flourish "out there" in society. Like the Berlin wall that once separated East and West Berlin, we have assumed there is a secular and sacred divide in art and have demanded that artists choose to operate in one realm or the other. This wall of separation is one reason the church has previously been ineffective in bringing change to Hollywood and other places where art and culture meet. Profound influence in the world's "arts and media mountains" will only occur when believing artists, who have been nurtured and championed by the church, are sent out to take their gifts to the world as God's presence and prophetic voice. Like light that dispels the darkness when it is plugged into a power source and turned on, the church will effect change by receiving the glorious dunamis art resident in heaven's courts and unfurling it throughout the earth to reveal God in new, exciting and tantalizing expressions.

Creator God's Spirit is within us. We have His mind and His heart! Let the wells of imaginative expression be uncapped and overflow in the church and into the world, unleashing the heart of our heavenly Father-Creator through creating sons and daughters. This is a kairos time and the winds of change are blowing! (Written by Janet Richards from Theresa Dedmon's interview with Sverre Bjørnhaug and Fredrik Skoglund)

God truly does have His heart set on transforming the nations! When I was in Singapore last year, we saw so many people get touched as we led people from the church in doing prophetic art treasure hunts. The following testimony is proof that *anyone* can see miracles happen! In the summer of 2008, I was speaking in Singapore at Church of our Savior during a prophetic arts conference. I taught everyone how to listen to the Holy Spirit through my husband's model called "treasure hunts." After training them on some simple prophetic art techniques, I released around 200 Singaporeans in groups to go out and find their treasure. Now first of all, you have to understand that most, if not *all* of them, were not used to going out in their city through Holy Spirit-led journeys, and this was the first time they had done an art piece in church, let alone one where they drew something to call out someone's destiny! As the teams assembled and were heading out, one woman named Claire came up to me in distress. She explained that her treasure hunt group had left and that she would have to stay in church and intercede. I looked in her eyes, and I knew that she was secretly relieved because she didn't have to go out. I turned to her excitedly, and told her that I would love to go out with her and help her find her treasure since I was done with my session. As I told her this, I could see the color drain from her face and her mouth open for a rebuttal, but she found no words to counter! She looked as if I had given her a death sentence! I took hold of her hand, and reassured her that I would be with her and that all she had to do was come and God would lead us to incredible treasures. She tried to find the words to back out, but my smile and the fact that I was "the teacher from Bethel" caused her to face her fears, and so our journey began!

Secondly, let me help you understand how foreign the concept of going out and blessing people in the marketplace is for most Christians in Singapore. Before we started the conference, we were able to do some shopping and this helped me to understand how open or receptive people would be in the marketplace for others to approach. It seemed to me, that the only interactions that took place were if they were buying something or knew someone in their group. As I tried to approach others in a casual way, they seemed very uncomfortable and surprised by my interactions with them. This was quite different than the western mindset, especially in California. Also, you have to be careful in how you share about Christ in Singapore, so I knew that when I asked the people to go out, they were taking not only a leap of faith, but were crossing over traditional lines of cultural taboos which kept the Kingdom message unseen by many. For me, this is one of the most exhilarating moments as a leader in revival! I get to equip people to carry the good news of healing and transformation not just where they go to church, but where they *live*! So Claire and I took off. I asked her to show me her picture and it was a simple pen drawing of a bird flying in the air. I could tell when she showed it to me that she was embarrassed because it wasn't "perfect' and that she didn't believe that a simple drawing that took five minutes could transform someone's life she'd never met. Yet, I had seen countless simple pictures heal and transform others in many countries around the world, so I knew she was in for the surprise of her life! As we left the building, we prayed that God would lead us to the right people.

About a hundred yards from the church building, we saw three Hindu-looking men sitting on a bench. I told Claire that we could start there, and she mentioned that "men" were not on her list. I told her that the Holy Spirit was with us and if these men were on our pathway, God had already set something up. Personally, every time I go out, I have to lean on every fiber of faith from past testimonies and God's love for others as I go. Fear tries to flood my gaze, but the testimonies crowd it out!

As I approached these three men, I was drawn to the one in the middle. I said, "Hello" and we exchanged names. Then I told him that Claire had drawn a picture for him and showed it to him. As he was looking at it, I was asking the Lord for a prophetic word for him that would change his life through this picture. I blurted out, "This bird represents your dreams. God is going to help your dreams fly higher than you could possibly imagine!" As I said this, my eyes were locked on his and I noticed that he was listening to every word I said. As we began to talk, I noticed the other two men got up, but this man was not embarrassed and didn't want to leave. God was moving! He said he liked the picture and thanked us. I asked him if he would share with us his greatest dream. He looked out into the sky and replied, "I would like to be the richest man in the world!" I told him that God is a good God and likes to partner with our dreams and asked if Claire could pray for him. He smiled and shook his head yes. All of a sudden this shy and introverted woman came alive! She took his hand and raised her other hand to heaven and began to pray out loud with courage and boldness! It was as if all heaven opened up around him. As we stopped praying, God gave me a word of knowledge and I asked him if he had any close relationships that were distant or broken. He said yes through tears and put his head down. I told him God wanted to heal those relationships and restore things that had been lost to him. He looked up at me and with tears streaming down his face, said, "You know having

God loves to show off when we risk everything!

those relationships restored back to me is worth more than a million dollars!" Claire and I again prayed for God to bring reconciliation in his relationships as well as reveal God's love for him during this difficult time. This broken man's life was being restored through a simple bird Claire had drawn! As we left, he turned and thanked us, saying he would keep this picture forever and that he would never forget us. Well, Claire's countenance was *radiant,* as you can imagine! She was beginning to see her destiny through releasing others into their own!

As we walked on, we had many encounters, in which we were able to pray and touch others. As we neared a market area, I saw many treasure hunt people huddled together, afraid to go out. I turned to Claire and said, "Now that you know how to do it, why don't you help lead other treasure hunters who don't know how to start conversations?" Startled, she began to have that look of terror again and she said, "Do you really think I am ready?" I touched her arm and smiled reassuredly, "Yes! You have already seen so many people get breakthrough, and others need you!" Confidence rushed back into her spirit, and she smiled as we broke up and helped others find their treasures. There were so many people that were activated. As we were returning, one man who had stopped going to church was given a picture. We had a word of knowledge about his back and he was healed! All the people in the treasure hunt group clapped! Someone had a clue about a person in an upstairs apartment that had a back problem, and he fit the description perfectly! He told us that he normally goes to the store a different way, but for some reason decided to go there by way of a different route and he happened to bump into us. He explained that he wanted to come back to church and be restored back to God. I asked them to pray for him and their faces became radiant just as Claire's had! As we were talking about the many miracles and the lives that were touched on the way back to church, we went by the bench where the Hindu man that Claire and I had met was still sitting. Yet this time, he was surrounded by another treasure hunt group. As we walked over, he turned to me and said, "There is the woman who changed my life! Here is the picture they gave me!" I blessed him and continued on. Later, I found out that that group had led him to the Lord! I found Claire and shared what had happened and as we both looked into

each other's eyes, we knew that together, we had been on an incredible journey that afternoon that we would never forget. God loves to show off when we risk everything!

These types of testimonies and more come pouring into our church on a daily basis. Miracles and profound joy are transforming believers, and churches are experiencing true joy in God's presence that has turned them upside down! And we get to distribute this newspaper of His goodness all over the world! The amazing reality of this journey is that it has just begun. The priceless truths hidden in Christ, which are commonplace in heaven, are and will be accessed through pioneers like John Wimber, who are just crazy enough to believe that God meant what He said.

The dream I have been looking for is so tied to all of our dreams. It is a dream in which churches do not limit the Holy Spirit's influence and presence; and where every person learns to walk in the full inheritance Jesus has already made available to them. As a child, my unspoken dream was to live a life free from fear and to live in a culture where others enjoyed God's presence and were transformed, bringing joy to others. And now this dream has run right into the reality of the hours in my day! It's funny; the revelation of all God created me to be was already alive in God's dream for me. And now it has been awakened! And the little girl who was too shy to talk to strangers, and the church that locked out joy and creativity have been set free!

Recently, I returned from a trip to the nation of Rwanda. I was asked to bring a team with me to release prophetic arts to touch people who had been ravaged by the Genocide in 1994, which ripped 1 million people off the face of the earth. We were invited to spend a week training a group of 60 students in 10 different creative workshops, including sewing, photography, dance, music, mixed media, writing, jewelry, drama, fine arts, and card making. In addition to training them in technical skills that could help then sustain a flow of income into their lives, we were on a mission to bring healing, restoration and *life* back into the hearts of these beautiful people! As we partnered with the Holy Spirit in leading the students into encounters with their heavenly Father and teaching them about their identity and destiny as sons and daughters, we began to see *radical* transformation coming to their hearts! Through the arts they were able to find their voice again as a people and began to creatively express the pain and devastation of their losses. Our hearts were absolutely wrecked with the realities of what they had experienced as many of the students shared their stories for the very first time in their lives. Some were forced to watch their entire families be killed before their eyes, others were made to be child soldiers, and a few were even buried alive. But as they expressed their stories through painting, writing, drama, or music, they began to see how God had been with them throughout every situation and that His love was there to heal them. One student in particular named Roger became such a picture to us of what God was doing in the entire group of students. He shared with us a story about what happened to him during the genocide. He was nine years of age at the time and was forced to watch rebel soldiers kill his entire family, and then afterward they threw him into a mass grave and buried him alive with dead bodies. He didn't know how long he was buried but after what seemed like days, a dog came around digging in the grave, and actually pulled him out, saving his life! As Roger expressed this story, he told us that he knew God was with him and had saved his life through that dog! After an encounter with the Father, Roger created a stamp that depicted his story so that he could make cards for everyone to see the faithfulness of God to him. Day after day, we saw countless physical and emotional healings through prophetic song and drama. The team and I were able to lead the entire group of students into encounters of inner healing and forgiveness. As they created art, their breakthrough in healing began. God

was turning what was evil into good! Through their paintbrushes, they released colors of unity and hope over their nation. Through dance, they brought back joy of celebration to break the spirit of mourning. Through drama and song, they began to prophesy from heaven into the identity of Rwanda and declare that everything the enemy had stolen would be restored and more! We were absolutely in awe of all the Holy Spirit brought forth in just one week of encounters through the prophetic arts. In addition to our workshops, we released the arts into the central prison of Kigali (Rwanda's capital city) by throwing a Christmas party for over 100 women prisoners and their children. We ministered God's Kingdom creativity in a dozen different churches in the city and released His love through the arts on the streets to prostitutes in the red light district. Everywhere we went, His redeeming love was made manifest and we saw an incredible number of salvations! By the end of the trip, we were truly filled with the conviction that when our Father said, "Ask of Me, and I will give you the nations as your inheritance," He meant it! There is no end to the redemptive power of His love, and the arts are an incredible way to unleash that love into the nations!

Where is next? I really don't know all God's plans for every country, but I do know that songs will be sung, dances will be danced, and art will be hung that will reflect the glory of the Creator once again in the halls of the nations. Are you ready for this? You have a part to play. Listen to His heart and you will see and hear what heaven is waiting to reveal to the nations!

GLOBAL ACTIVATION EXERCISE:

Pick a nation that you want to impact and the Holy Spirit is highlighting to you. Then turn on some soaking music and begin to ask the Lord for a picture or word for that country. Begin to draw this as you intercede and release God's presence to this place. You may even want to put it up in your prayer room. You can also activate the other art forms by dancing over this country, singing a prophetic song, or doing a prophetic act to release a blessing over this place. Be creative and have fun! Let your intercession breathe life through these art forms into every part of that country! Take time after you are done, and declare what you saw in intercession as you created with the Holy Spirit. Keep track of that country in the next couple of months and look for answers to your prophetic art intercession! You can do this exercise either individually, in a group, or with children as well.

TESTIMONIES FROM GLOBAL ACTIVATION EXERCISE:

❧ CONCLUSION ❧

Where do we go from here?

We hope that you have enjoyed this manual! If you are adept in various art forms, we want to challenge you to let the Holy Spirit free you to enjoy the process of His presence as you create. There is nothing like excellence marked with Holy Spirit anointing! We pray that your arts will be prosperous and touch many lives. As you have read through these chapters and gone through the activation exercises, God is imparting to you a spirit of creativity from heaven, which you can apply to any area of your life – not just the different art forms. Creativity in the kingdom can and will be one of the major influencers in this new phase of the kingdom of heaven coming to earth.

If you are just branching out to discover your God-given creativity, our hope is that you learn the value and unique giftings that can only flow through you. It is time that we become free to explore who we are without fear of being different or measuring up to standards not set by God, but man. Everything you create is marked by presence when you are free to create in joy with the Holy Spirit. Some of the greatest works of art will be created through people who have learned to enjoy His presence! Great mysteries are revealed to those who are free to know God in the context of Creator as well as Savior and Healer. So have fun and find out how much He loves you as you create in anointed worship to Him. After you face your fear, the next step is to grow in technical expertise so that you can hone in on your gifting as well as anointing. This does not negate natural ability, nor hours set side to master a craft in excellence, but it addresses the truth that our starting point is knowing God's pleasure as we create with Him.

Now, let's turn our gaze to the world we are creating around us. You see, we owe the world an encounter! The arts have always been an outflow of what a culture holds as relevant. Let's see those around us through Jesus' eyes. He loves to celebrate, create, and touch others through all the art forms. Let God open up your eyes to the power of your arts to change your city and the nations. I have a dream that one day we will wake up to our partnership with the Creator of the Universe and there will be art that heals people as they stare into Holy Spirit-dripped colors of paint. I dream of movies and films created with excellence that depict the heart of the Father, bringing prodigals home. I have a vision of music, which not only frees the demonized, but shapes values to glorify the Kingdom and the Creator. Soon I foresee that there will be churches producing books, scripts, dances, and art pieces that prophesy for centuries to come. I also have a dream that the next generation's legacy in the arts will surpass all that we have presently accomplished. If we can become a voice of excellence and anointing, we will gain relevance in the Arts mountain of society.

Let's get out of the box and dream of a world made for His glory and not limit our vision to yesterday's triumphs or today's constraints, because "eye has not seen, ear has not heard, no mind has conceived, what God has created for us who love Him- but we have the mind of Christ." (I Corinthians 2:9,16) Let's now discover it!

❧ APPENDIX OF PROPHETIC ART ❧ RESOURCES

PROPHETIC MEANINGS FOR COLORS

Amber The glory of God, The Father's heavenly care

Black The mysteries of God, the secret place, depths

Blue Heavenly, prophetic, Holy Spirit, grace, revelation, knowledge, the river of God, life-giving flow of the Holy Spirit

Brown Humanity, earth, harvest, sowing, humility, seed

Burgundy/wine The new wine, the cup of the new covenant, blessings, rejoicing, the blood of Jesus, the Bride of Christ

Pink Joy, compassion, healing, friendship, deep place of the heart, romance of God

Gold Deity, wealth, royalty, refining fire, glory, majesty

Green New beginnings, growth, hope, restoration, happiness, springtime, birth

Iridescent white Angelic presence, blessings of God's truth

Lavender Transparency/vulnerability, fragrance, intercession

Orange Courage, passion, dunamis power, fire, harvest, strength

Purple Royalty, kingship, sonship, inheritance, richness, abundance, infilling of the Holy Spirit

Red Atonement, the blood of Jesus, sacrifice, redemption, love

Silver Redemption, Holy Spirit, freedom to create

White Purity, holiness, righteousness, peace

Yellow Courtship with God, intentional pursuit, the glory of God

⇥ PROPHETIC ARTS TREASURE HUNT ⥽

1. Draw a prophetic art piece for someone you will meet. It can be in card form or make a simple picture.

2. Each person writes down words of knowledge in the spaces allowed for each category below:

LOCATION (stop sign, store, bench, house, etc..)

_____ _____ _____ _____

A PERSON'S NAME

_____ _____ _____ _____

TYPE OF ARTS TO BLESS THEM WITH (drama, art picture, balloon animal, song, prophetic card, word)

_____ _____ _____ _____

A PERSON'S APPEARANCE (color, clothing, hair, etc)

_____ _____ _____ _____

WHAT THEY NEED PRAYER FOR (knee, back brace, tumor, ears, etc.)

_____ _____ _____ _____

THE UNUSUAL (Lollypop, dolphins, neon green pinwheel, etc.)

_____ _____ _____ _____

3. Gather together in your group, put your clues together and decide where you will go. Choose a beginning location.

4. Look for people or things that match clues on your list or that you feel the prophetic art is meant for.

5. When you find something on your list, let the holy spirit journey begin!
- Approach the person, show them the art piece and say something like:
 "This may seem a little odd, but we're on a treasure hunt, and I drew this card for you."
- Explain the art and ask if it means something to them.
- If you have clues, show them your list.
- Build rapport (Make connection/show value for them. Ask questions about them to get to know them.)
- Give them the prophetic word that you have and speak blessing over them.
- Ask if you can pray for them. Pray for healing or for other needs… "Is there anything in your life that you wish could change?"

6. If they say "no"…
- Build more rapport (common ground, friendship.)
- Ask the Holy Spirit what He wants to highlight about the person.
- Give them some encouraging words (prophesy).

7. Ask again if you can pray for them…
- If they say no again, bless them and go to the next person!
- If they say yes, ask for God's presence to come- command the pain to leave, life to come, etc.
- Ask them to test it out. "Do something you couldn't do before we prayed."

8. When they are healed…
- Explain what happened! "This is God's way of showing you His love and that He is real."
- Ask them if they would like to know Jesus personally!
- Invite them to ask Jesus into their life!

9. Go to the next appointment! Write down testimonies!

❧ PROPHETIC DRAMA ☙

THE FATHER GETS HIS KIDS BACK

This drama is great both for children's ministry in a church or for ministry in an outreach/open air setting. If you can get the children interested in what you're doing, you will probably have the attention of their parents, as well.

PREPARATION TIME:

 This is a simple but very moving drama, so you can practice it for about an hour beforehand (before you leave the country) and then a couple times when you arrive at your destination. You can also have nationals and children from the church where you are activating be a part of the drama so that they can continue to do dramas after you leave.

CAST:

Narrator _____ (Interpreter, if needed)

Father God _____

Jesus _____

Satan _____

2 people who nail Jesus to the cross _____ _____

Children:

Painter _____

Singer _____

Dancer _____

Ball Player _____

Runner _____

KEY:

 Many times on missions trips it is good to activate children ages 9-13 to play a part in this drama either by creating more roles/parts for children to play and adding to the story or giving them one to two spots in the existing cast. This makes them feel a part of the drama. Don't have *all* of them be the children as you need your team to show them what to do in the drama.

IMPROV AND MIME:

Children and people like humor and characterization, so exaggerate the parts. We painted a mustache and dark eyebrows on Satan once, and another time someone had a rope, which Satan put around the children. Miming the different objects like the ball, paintbrush, etc., is great too! Just remember that you need to make it realistic in a mime (ie: *when you throw, someone has to see them catch it*).

MULTIPLE TEAMS:

Many of you will be going on mission trips and splitting up during the day to reach other cities or areas. You can teach this to multiple groups of people so that there can be multiple children's performances going on.

IMPORTANT PARTS:

God the Father, Jesus, and Satan are your key roles, so find strong people who can make these characters come to life!

"THE FATHER GETS HIS KIDS BACK"

by Theresa Dedmon

SCENE:

Jesus is sitting on the ground with His back to the audience stage left, while the children are curled up, sitting on the ground center stage. Satan is sitting on the ground with his back to the audience on stage right. God the Father is standing over the first child who is a painter and follows the actions while the cast responds to the narration.

NARRATOR:

God the Father had a wonderful, fantastic out of the box idea. He would make children *[starts to mold first child]* of all different kinds of sizes *[Father helps first child up]*, shapes *[follows the line of the child's body]*, and colors *[mimes painting their face with a paintbrush]*. He would give them all kinds of gifts *[then hands that child a paintbrush and shows them how to paint. Both are enjoying the process]*, talents, and personalities that would reflect and look like Him. After all they were His kids!

The first one took their paintbrush and began to paint beautiful sunsets in the sky and mountains on the earth. They even painted hearts on God the Father. God the Father thought this was so funny *[they both laugh and paint together]*. [Note: *As each child is highlighted, all others freeze who were previously made unless they are invited into narration.*]

Then He turned to another form and began to mold and shape them, giving them the gift of singing. First, God the Father sang over them, and then they sang back to Him. They would sing really loudly and then really softly, quiet like the rain. Then he made another child and gave them the gift to dance. God the Father would twirl them and dance with them, and the other children would even join in with them! Next, He formed another child and gave them a blue ball to play with. God the Father would throw the ball and play games with them for hours! *[Wait for*

awhile and focus on them playing before continuing narration]. Then he touched another child and He made them fast. God the Father would chase them all around, and they would hide from Him, but He would always find them!

[All the children begin to play and use their gifts while God the Father goes around to each one smiling and playing with them]. It seemed like everyone was happy with what God the Father had made them to be until the enemy *[narrator's voice changes at this time to reflect evil has entered in]* came and began to whisper in their ears, saying that others' gifts were better than what they had received. They tried to take each other's gifts and began to hate what God had given them. Satan told them that God was to blame and that He wasn't really nice at all. He told them to come away with him and forget about what Father God had said about them. *[Enemy is whispering in their ear and drawing them away to stage right while God the Father has His hands out pleading for them to come back].* The enemy told them lies about the Father and made the children leave His presence *[they all leave with Satan and stick out their tongues at God the Father and look angry at Him, while God the Father looks sad.]*

When Satan realized they were away from God, he took away all of their gifts which made the children cry. He even hurt them *[breaks a child's leg or arm]* and took away all their laughter, joy, and love- and they began to get angry at each other! It was awful. But then they remembered how they loved playing with God the Father and cried out for help! *[Enemy has them roped up while they cry out.]*

God the Father heard their cries and asked His Son, Jesus *[Jesus gets up and the Father shows Him the children and He nods His head gesturing that He will go]* to rescue them from Satan. Jesus came and taught them how to love again and healed those who had been hurt. The enemy became angry and said that the children could never go back to the Father because of what they had done. Jesus said that He would die so that they could be free! Satan laughed and had his evil ones kill Jesus, thinking God the Father could never help them now. *[They nail him to the cross while the children are down below crying.]*

But boys and girls, God's love is stronger than any hate. How many of you can say 1-2-3? Yes, Jesus died, but after 1 *[all repeat with narrator]*, 2, 3 days *[narrator yells]* Jesus comes back to life!!! *[All of the children in the play stand up and cheer and hug Jesus.]* Then Jesus told Satan to give back what He had stolen from them, and He had to give back all of the children's gifts to Jesus. Then Jesus kicked the devil out of their party *[Satan is literally kicked out by Jesus]*! It was a celebration day!! Jesus gave back to each child what the Father gave them *[narrator stops as Jesus gives back the gifts.]* The children were so excited that they began to create wonderful things!! But the best part was that Jesus created a way for them to go back to the Father!! *[Jesus leads them to the Father.]* The children of God hugged and cried with the Father, thanking Him for loving them even when they had turned their back on Him and asked Him to forgive them. And of course, He did! What a celebration! The Father had His kids back! There was dancing, food, singing, and lots of hugs! *[Narrator stops while crowd enjoys the party. Then narrator starts to come toward the children in the audience and addresses them. The cast stops and holds hands and moves forward toward the children as well.]*

Would you like to go to this party? Would you like to know what it's like to know the love of Father God and know what gifts He has given you? If you would, please raise your hands *[can have them stand up.]*

[Person or narrator then leads them in salvation prayer and then the cast can give words of knowledge about what gifts each person has. You can also lead the children on an encounter where they picture Father God giving them a gift. Have them open it and then have them share what gifts they received.]

** At this point you can have the celebration with face-painting, balloon animals, and prayer for healing. Before you break for this time you can also talk about how God heals people and how He healed the one who got hurt in the play and ask if someone is sick or has a family member who is sick!*

** It's good to invite kids and people to the service who saw the skit if you are doing it in the villages during the day time.*

IMPORTANT THINGS TO REMEMBER:

- When performing this drama, it is very easy for things to look messy because there are so many people on stage. Make sure that when the narrator is talking about a specific character that that character can be clearly seen.
- Don't be afraid to pause in the narration to let an action play out. We want to see Father God having fun with His kids. We want to see Satan getting kicked out of the party, etc.
- If you are in a foreign country, get the church and the locals involved. Show them how easy it is! It's also a great way to connect with them and break barriers between them and the "Americans."
- Have fun! With kids, the bigger and sillier the better! If you are having fun then you will keep their attention longer and attract more people if you are doing it on the street. It is especially important for the narrator to be animated.

❦ Keys to Releasing Prophetic ❦ Destiny Through The Arts

Core Values of an Arts Kingdom Prophetic Mindset

- Prophetic: encouraging, comforting, positive, loving, and truthful

- Art: unique, creative, moving, passionate, fluid, and God-breathed

"Inhibitors" to Prophetic Art

- Critical comments or experiences

- Judgments you or others have made about what you have created

- Society's standards and expectations

- Waiting until you feel you are "good enough"

- Valuing the creative works of others but not your own

Prophetic Art Releasers

- Understanding and perceiving how you delight God!

- Feeling God's pleasure and presence as you create

- Closing the door to the lies you have believed about yourself and your ability to create

- Becoming free in creating anything and seeing it as good

Biblical Framework

- We are made in God's image (Gen 1-3)

- God created everything – and it was *good* (Genesis 1-3)

- You were born to co-labor with God (Ephesians 1:3-5 - Neo from the Matrix)

- We can create more life in His presence than a thousand classes can impart

Everything You Create is Unique and Good

- We were created to be free (Gal 3:25-28)

- Your act of declaring and creating produces life!

Transforming Kingdom Core Values that Shake Off the "Old Wineskin" of Creativity

- Generosity and honor replace earthly wisdom and a poverty mindset!

- Freedom to be different yet valued replaces shame in coloring outside the lines!

- Empowering others higher than ourselves versus fear of losing our place!

- Relying on God's limitless creativity and imagination replace trust in skill alone!

- God's unconditional acceptance, love for creativity, and diversity replace performance-based worth and perfectionistic standards!

- Filling up in His presence yields greater fruit in changing lives through our art form than anything else!

Learning to Encounter His Presence

- Engaging in corporate encounters!

- Importance of hearing God's voice and letting go!

- God's voice has to be the deciding factor of your worth and creativity!

❧ ARTS ON STAGE ❧

BASIC PROTOCOL AND GUIDELINES

There are very practical instructions and keys that we use with our "Arts on Stage" teams at Bethel! We want to make these available to you to help you get the arts started at your church as well! We have experienced this to be such a powerful ministry both unto the Lord and to people. One of the most important things to do if you desire to start using prophetic arts in worship is *to connect with your church leadership* and find out what their core values and desires are for this type of ministry. Honoring them and serving their vision as the prophetic arts are released is key to honoring *the Lord* and to creating a resting place for His presence! The guidelines below refer particularly to painting on stage/in the front of church as part of the worship times but using arts during worship is not limited to painting alone. We have had artists draw on huge pieces of paper, do watercolors, drape fabric on mannequins, write prophetic poetry, etc. Ask the Lord what He wants to release!

EXPECTATIONS FOR LEADERS

- As a leader, you are the covering for your team, to coordinate setup and prayer together, to tap into what Holy Spirit is saying over that service, and to make sure that church staff/leaders are honored by complete clean up and tear down of our supplies for each service.

- You are paired up with another leader so that you can cover each other! Partnership is powerful!

- You are responsible to oversee complete setup and tear town of all arts supplies on the stage. This looks like: easels, water, brushes, paints, paper plates, paper towels, *tarps* to cover floor and table, etc.

- Love on your team! Some people are first time painters so make sure you encourage them and get them *really filled up* with the Holy Spirit! As you pray together, get input from each team member on what they're seeing and feeling in the Spirit and *pray* into that together!

EXPECTATIONS FOR TEAM

- Make sure you know *when* you are scheduled to paint, and if you cannot make your shift, *contact* another member of your team to *cover* for you.

- You must be at the church *one hour* before the service *–please be on time!* This time is crucial for setup, team unity in the Spirit, and connection with the leaders overseeing your service. After cleanup, connect *again* as a team in the hallway *before* anyone leaves, to make sure everyone feels good.

- *Very Important: The whole team* (not just the leader) is responsible for total cleanup and tear down! Don't leave someone to handle all the mess, please! Cover each other!

IMPORTANT THINGS TO REMEMBER

- *Please dress modestly*, especially if you're on the platform. Be aware!

- Make sure that the platform/floor is *well covered* with tarps, and that the easels and table is positioned over them! Let's honor the maintenance staff by not making messes for them.

- Make sure easels do not block people's view of the worship team.

- If you desire to sell your artwork, those connections are up to you. Please do not leave your paintings at the church. Take them home with you!

ADDITIONAL RESOURCES FOR CULTIVATING A KINGDOM LIFESTYLE

BOOKS
(Available through ibethel.org)

The Ultimate Treasure Hunt - Author: Kevin Dedmon

Unlocking Heaven: Keys to Living Naturally Supernatural - Author: Kevin Dedmon

Dreaming with God - Author: Bill Johnson

Basic Training for the Prophetic Ministry - Author: Kris Vallotton

Here Comes Heaven (For Introducing Children to the Supernatural) - Authors: Bill Johnson and Mike Seth

CD TEACHING SERIES
(Available through ibethel.org)

Awakening an Arts Renaissance - Teaching by: Theresa Dedmon

Preparing for Supernatural Encounters - Teaching by: Theresa Dedmon

WEBSITES

www.theresadedmonministries.com - Bethel Prophetic Arts/Theresa Dedmon Ministries
(Launching February 2010)

www.ibethel.org - Bethel Church Redding, CA

www.healingherald.org - Healing Herald (Passing on the Legacy of Revival through Testimonies!)

www.adoriadesigns.com - Adoria Fashion Studios

IMPART PROPHETIC ART CARDLINE

Imagine greeting cards that release the *life* of God's Kingdom through prophetic art and testimonies of healing, encounters, and the love of God poured out into people's lives! Each card has been intentionally designed to be an *impartation* of the goodness of God into a person's life, whether they need healing, encouragement, joy, or a "Happy Birthday" that calls them into their destiny!

If you are interested in further information on ordering our prophetic cards, please email us at:
impartcardline@gmail.com